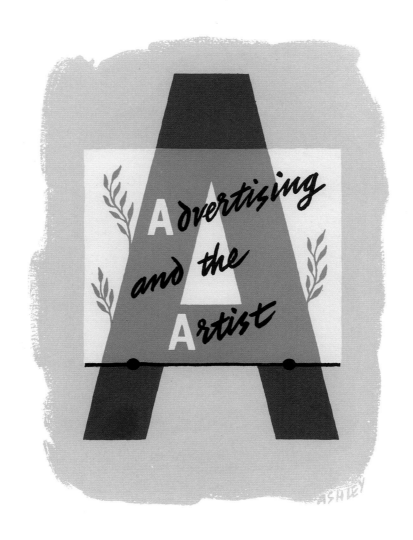

Advertising and the Artist

ASHLEY

Advertising and the Artist
Ashley Havinden

MICHAEL HAVINDEN · RICHARD HOLLIS · ANN SIMPSON · ALICE STRANG

NATIONAL GALLERIES OF SCOTLAND · EDINBURGH · 2003

Published by the Trustees of the National Galleries
of Scotland to accompany the exhibition *Advertising and the
Artist: The Work and Collection of Ashley Havinden* held at the
Dean Gallery, Edinburgh, from 15 October 2003 to 18
January 2004

ISBN 1 903278 37 6

Designed by Dalrymple
Typeset in Walbaum and Gill by Brian Young
Printed in Britain by Butler & Tanner Ltd

Cover: front cover adapted from Ashley's design for a
brochure for Chrysler, 1929, illustrated on back cover

Endpapers: from Ashley's brochure for Richard Shops, 1949

Half-title: adapted from Ashley's jacket design for
Advertising and the Artist, 1956

Frontispiece and page 95: line drawings by Ashley Havinden
from *Line Drawing for Reproduction*, 1933

All works illustrated are by Ashley Havinden and
are held in the Ashley Havinden Archive at the Scottish
National Gallery of Modern Art, Edinburgh, unless stated
otherwise. Many of the advertisements shown were
collaborative, with Ashley working as art director
alongside copywriters, illustrators and
photographers.

ASHLEY

FOREWORD

The Ashley Havinden Archive encompasses some forty years of advertising design when Ashley Havinden (referred to hereafter as 'Ashley', the signature he used throughout his career) worked as the remarkably innovative art director of W.S. Crawford Ltd, the celebrated advertising agency. The exhibition, which this publication accompanies, is a carefully selected cross section of a mass of material. One of the major roles of the National Galleries of Scotland encompasses design and not only 'disegno' in the Renaissance meaning, a word which is almost impossible to translate, but 'design' through the ages and through a great gamut of styles. Nowhere is this concept of design comprehensively documented and addressed in Scotland – as it is at the Victoria & Albert Museum in London, the Kunstbibliothek in Berlin, or the Musée des Arts Decoratifs in Paris. A decade ago we started to put together a serious historical collection at the National Gallery of Scotland, and the fruits of our labours were reflected in the exhibition *Designs of Desire*, 31 March – 15 June 2000, a show which toured from Edinburgh to the Burrell Collection, Glasgow, Temple Newsam House, Leeds, and Canada House, London.

During the fin de siècle, magnificent designs by Charles Rennie Mackintosh and his Glasgow contemporaries abounded in Glasgow. Both the finished artefacts and designs by these artists are collected at the Hunterian Museum and Art Gallery and Kelvingrove Museum in Glasgow. Added to these, distinguished three-dimensional artefacts designed by major international designers have been collected recently by the National Museums of Scotland in Edinburgh. What we need to do now is to put together a carefully chosen small corpus of twentieth-century drawings for posters, fabrics, stained glass, architecture, furniture, industrial products and household utensils. This follows the precedent of many modern art galleries, but above all by the Museum of Modern Art in New York. By doing this we can join all our collections in a meaningful way, from Dürer to Bernini, from Le Brun to Robert Adam,

from Pugin to Christopher Dresser, E. McKnight Kauffer to Paolozzi and beyond.

The Ashley Havinden Archive, generously donated to the Scottish National Gallery of Modern Art by the Havinden family, provides us with the work of a most versatile and productive designer that neatly fits into such a stylistic progression. The exhibition is witty, innovative and discursive and often we are privileged to be privy to Ashley developing his artistic ideas. The acquisition of the archive can be seen as something very special and rather different for Scotland and above all a fascinating tool for those intrigued by design itself and by designers of all epochs.

Much of the material illustrated in this publication is in the permanent collection of the Scottish National Gallery of Modern Art. We owe an enormous debt of gratitude to Ashley Havinden's son and daughter, Michael Havinden and Venice Lamb, for their generosity in making this possible, and to their respective spouses, Kate Havinden and Alastair Lamb. The exhibition and catalogue mark an important stage in the Gallery's thirty-year relationship with the Havinden family, which began a few months after Ashley's death in 1973. We are doubly grateful to Michael Havinden, who has written a biographical memoir of his father, assisted by Venice Lamb, and would like to thank here the other external contributors to the catalogue: Richard Hollis for his incisive essay on Ashley's work in advertising and Alan Powers and Brian Webb for their authorship of some of the captions. We are also very grateful to the following: Judy Allan, Kraft Europe (Birds); Derek Barrett; Anna Baruma, archivist, Liberty & Co., London; Jessica Bissett; Alan Bowness; Paula Bricki, archivist, BP Archive, University of Warwick; Florisa Gatty, archivist, Martini Archive, Bacardi and Company Limited; Madeleine Ginsberg, DAKS; Lynn Grant, Philip Harley, Christie's London; Jennifer Havinden; Rosalind Horne; Tim Jones, English Heritage; James Kirkman; The late Maria and Alex Kroll; Michael Phipps, Henry Moore Foundation; Tim Pethick, Tim Pethick Design; Elena Ratcheva; Naomi Skelton, Connaught Brown; Gees-Ineke Smit, KLM Art, Photo and Graphical Collection; Ian Royce, GlaxoSmithKline (Eno's); Jackie Seargeant, archivist, Dewar's Scotch Whisky; Peter Southgate, DAKS; Susan Tebby and Margaret Moran, Margaret Timmers, Victoria & Albert Museum, London. Finally, we are grateful to Ann Simpson and Alice Strang who curated the exhibition which this publication accompanies, as well as to Christine Thompson, Graeme Gollan, Marianne Wilson, Terry McCue, Ian Craigie and Keith Morrison and their many colleagues at the National Galleries of Scotland who have enthusiastically brought this project to life.

SIR TIMOTHY CLIFFORD
Director-General, National Galleries of Scotland

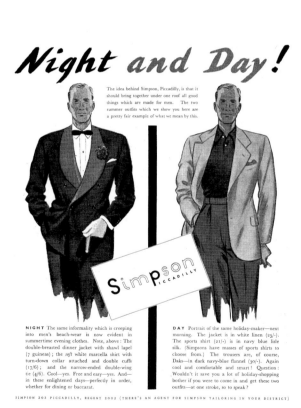

I Press advertisement for Simpson Piccadilly, 1930s

INTRODUCTION

This publication, and the exhibition which it accompanies, commemorates the centenary of the birth in 1903 of Ashley Havinden, one of the most brilliant British advertising artists of the last century. It also marks the thirtieth anniversary of the Scottish National Gallery of Modern Art's long and fruitful relationship with the Havinden family. In October 1973, following Ashley's death in May of that year, his son and daughter approached Douglas Hall, the then keeper, to see if the Gallery would be interested in accepting on extended loan works from Ashley's collection of modern art. As their mother Margaret Havinden – Ashley's widow – was Scottish, and since both parents had been employed for most of their working lives by W.S. Crawford Ltd, the famous advertising agency founded in 1914 by a remarkable Scot, Sir William Crawford, they felt that Scotland's national collection would be an appropriate home for such an impressive group of works.

In 1973 the Gallery had been in existence for little more than a decade and, with relatively few purchase funds at its disposal, was reliant on loans and gifts to cover the ever-expanding range of movements, styles and individuals that made up twentieth-century Western art. In December 1973 the Havinden family placed eleven works on loan by the following artists: Herbert Bayer, Reg Butler, Alexander Calder, Barbara Hepworth (three sculptures), F.E. McWilliam, Kenneth Martin, Victor Pasmore, William Scott and Takis. From the outset the Gallery hoped to acquire Calder's *Spider* c.1938 and one of the three Hepworths, *Wave* 1943–4. We purchased the former in 1976 and succeeded in acquiring the latter, with assistance from the Heritage Lottery Fund, National Art Collections Fund and Henry Moore Foundation, in 1999. Havinden had bought *Wave* from Hepworth in August 1945, when he and Margaret were holidaying in Cornwall. The Gallery also acquired Martin's *Screw Mobile* 1959 (a gift from the Havinden estate in 1976) and Butler's tiny iron *Personage* 1949, purchased in 1977. Other works remain on loan.

At the same time that the Gallery was gratefully receiving works of art on loan from the Havinden family, negotiations were under way regarding the future of Ashley's archive. As art director of Crawfords for nearly forty years, Ashley was responsible for many stylish and innovative campaigns, for clients as diverse as Chrysler Motors, Eno's Fruit Salt, Gillette, Simpson Piccadilly, Martini, Pretty Polly and Yardley. In the 1930s he also made a name for himself as a designer of rugs and fabrics, and as an abstract painter. In 1937, for instance, Ashley had solo exhibitions in London of his rugs and textiles at Duncan Miller Ltd, and of his abstract paintings at the London Gallery, founded the previous year by another former Crawfords' employee, Noel or 'Peter' Norton.

When, in 1978, I organised the exhibition *Alastair Morton and Edinburgh Weavers: Abstract Art and Textile Design 1935–46*, I made extensive use of Ashley's archive. For example, we exhibited the following – all of it by the multi-talented Ashley and much of it borrowed from his archive: textiles and textile designs commissioned by

his friend Alastair Morton for Edinburgh Weavers; publicity material for the parent company, Morton Sundour Fabrics Ltd; stationery and brochures for the London Gallery; as well as a number of Ashley's own paintings and works from his collection of contemporary art. The Gallery, for this reason, seemed an obvious choice as an eventual home for this material, especially when it became clear that new storage and study facilities would become available with the opening of the Dean Gallery in 1999. Consisting of some 50,000 items, the Ashley Havinden Archive includes most of the printed work for Ashley's design campaigns, as well as correspondence and other documents from his forty-five years at Crawfords (1922–67), preparatory drawings, photographs, glass negatives, sketchbooks, scrapbooks, original artwork and textiles; there are also over 200 examples of printed material by other artist-designers, for example E. McKnight Kauffer, whom Ashley employed at Crawfords in 1929–30 and whose work he greatly admired. This extraordinarily rich resource has now been catalogued by Ann Simpson and her team and is open to scholars.

The title of both publication and exhibition, *Advertising and the Artist*, echoes that of the slim but densely illustrated volume published by *The Studio* in 1956 in which Ashley cogently summed up his ideas on visual communication based on many years working in the advertising industry. It is a book that still has much to teach students of graphic design today.

RICHARD CALVOCORESSI
Director, Scottish National Gallery of Modern Art

2 Design for Vulcain watches, 1929; these Swiss watchmakers advertised worldwide through Crawfords. Ashley's illustration is in a slightly abstracted symbolic style as used by other artists of the period such as Paul Nash and Eric Ravilious.

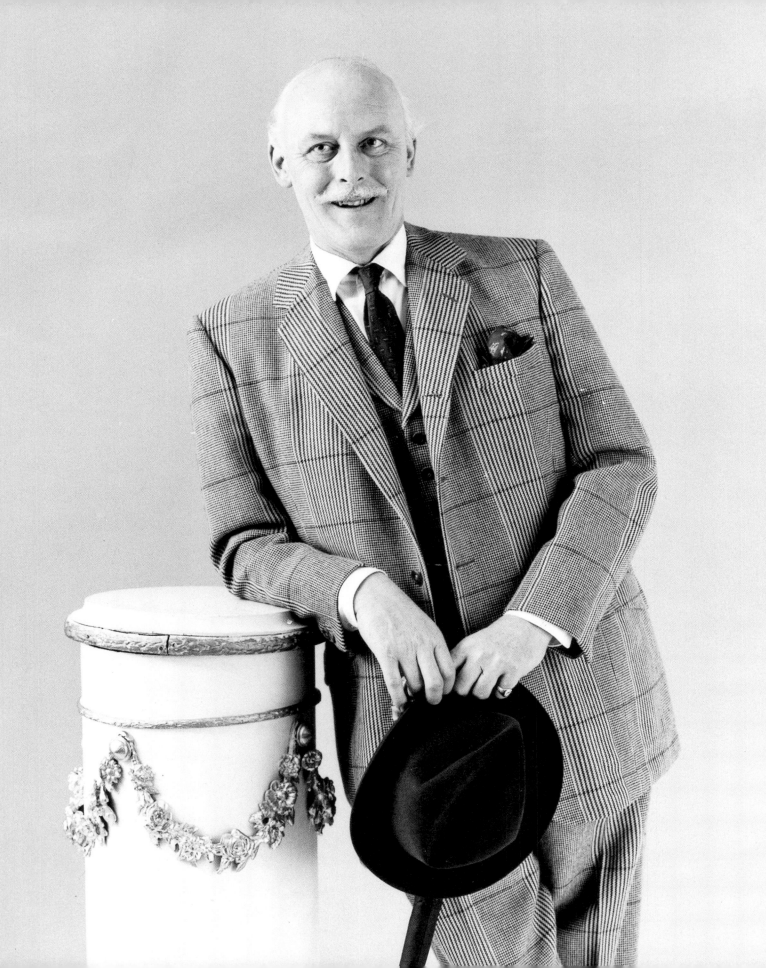

ASHLEY HAVINDEN 1903-1973
LIFE AND WORK

Michael Havinden

3 Ashley, 1961. Photograph for an article
by Kenneth Martin, 'A Man and his Clothes' in
Man About Town, January 1961
Private collection

Ashley Eldrid Havinden's start to life gave no hint of his future prominence as one of Britain's leading commercial artists. He was born on 13 April 1903 at Maidstone in Kent, to Gustavus Havinden and Nellie Latter. His father, the son of a London wine merchant, was an ambitious businessman whose career was full of ups and downs; he certainly had no artistic inclinations, so if these can be inherited, they were passed on to Ashley from his mother. Tragically, she died of diphtheria when Ashley was only nine years old. Ashley and his four brothers and sister subsequently acquired two stepmothers, but he was never close to either of them.

Ashley's father managed to have him nominated, along with a few other deserving pupils, for a free education at Christ's Hospital, Horsham, West Sussex. Eight years later, at the age of seventeen, he left school without any formal qualification, though he was awarded a gold medal for winning a swimming race. Although he wished to be an artist, his father thought he should go into a more rewarding activity such as advertising. This unpromising start to Ashley's career began in 1920 with a lowly post as a trainee at Waterlow and Langton, a printing company in Watford, where he remained for a year, and then a six-month job with the Sun Engraving Company, also in Watford. Once he was so bored that he fell asleep in the darkroom, though he came to appreciate that he had gained valuable experience of lithographic and photogravure printing and block making: skills that were to form an essential part of his future work in advertising.

The following year, 1922, was to prove momentous for him. He was introduced to an acquaintance of his father, William Crawford, the Scottish businessman who had set up an advertising agency in London in 1914. Ashley was employed as a trainee at £1 a week, but remained with W.S. Crawford Ltd for the whole of his career, becoming art director in 1929, at the age of twenty-six, and eventually vice-chairman. He was fortunate that William Crawford (who was knighted in 1927) was a remarkable

4 Ashley Havinden, 1930
Private collection

5 Margaret Havinden, c.1930
Private collection

and unconventional man who gave Ashley freedom and encouragement, which was rare at that time and especially for one so young. He was also exceptional in that he treated women as equal to men [**6**]. Margaret Sangster, a Scot like Crawford, was a good example of a talented account executive, whom Crawford also made a director in 1929, as was her elder sister, Florence Sangster, who became finance director and later vice-chairman. Crawford realised that women knew much more about shopping than men and in his 1938 book, *It's Human Nature*, wrote 'while a man is talking shop about golf a woman is talking shop about shops'.

A brilliant copywriter called Bingy Mills joined Crawfords in 1925, and together with Margaret [**5**] and Ashley completed the advertising trio that formed the nucleus of a creative group. Bingy wrote the copy, Ashley provided the layout, typography and illustrations, while Margaret sat in judgement. She also made the contacts with the clients and saw the work through production. It was during this period, starting from 1926, that the group was responsible for producing advertising campaigns for Pennsylvania Hotel New York, Chrysler Motors, Eno's Fruit Salt, Marsh Hams, Western Electric Sound Systems for cinemas, Dewar's Whisky and Kayser Silk Stockings. Many of these advertisements broke new ground and initiated a completely fresh style in English commercial art. In Ashley's design for Eno's Fruit Salt, for example, the aim of the layout was to give an impression of cleanliness and sparkling vitality – not leaving it to the copy to tell the story without pictorial support. The introduction of the Chrysler car to England gave Ashley another opportunity to establish this new style in advertisement design, which he grasped with outstanding effectiveness.

Of course, Ashley did not pioneer these new styles in advertising art on his own. He was the first to admit the importance of certain key outside influences in the development of his art. Some of his earliest influences were from the typographer, Stanley Morison, whom Ashley first met in 1924, and the publishers, Harold Curwen and Francis Meynell, all of whom represented a typographical renaissance in England at that time. Morison had a great effect on Ashley as he inspired him to dedicate himself to the improvement of general design and typography in commercial art; an endeavour that continued all his life.

Another important influence was the American poster artist, Edward McKnight Kauffer, who worked in London and who became a close friend together with his wife, Marion Dorn, herself a distinguished rug and fabric designer. Kauffer's many posters for London Transport were dramatic and unconventional and were much admired by Ashley. Kauffer's book, *The Art of the Poster, Its Origin, Evolution and Purpose*, 1924 was an important addition to Ashley's library, and he later arranged for Kauffer to work freelance for Crawfords in 1929–30.

A third major influence on Ashley, and one of the most profound, came from the new ground-breaking work in typography and design taking place in Germany during the 1920s, particularly the examples set by Walter Gropius's famous Bauhaus in Dessau. In 1926 Ashley and Crawford went to Germany, with letters of introduc-

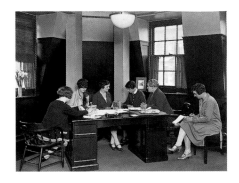

6 Women's Advertising Department, W.S. Crawford Ltd, c.1927. Left to right: Miss Morell, Kathleen Maclachlan, Margaret Sangster, Miss Stoqueste, Antonia White

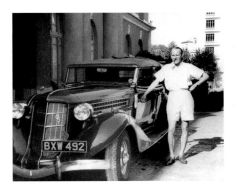

7 Ashley with his Auburn car in the south of France, c.1938
Private collection

8 An early Chrysler advertisement with the lettering that was to become the Ashley Crawford typeface, 1926

tion from Stanley Morison, with the purpose of visiting the famous type foundries of Gebrüder Klingspor at Offenbach-am-Main and the Bauer Type Foundry at Frankfurt-am-Main. They also met Professor Otto Hadank, the leading designer of trademarks in Germany, who was becoming increasingly famous for his series of beautiful package designs for Haus Neuerburg, the cigarette firm.

The trip to Germany opened Ashley's eyes to many exciting design possibilities. British advertisers had much to learn, and to help inspire them they brought back a mass of German material. The German influence bore further fruit for Ashley in 1927, when Crawfords decided to open a branch office in Berlin, partly because of William Crawford's interest in German design potential and partly to handle more efficiently the American Chrysler car account. Crawfords were responsible for the Chrysler account for the whole of Europe as well as England and Ashley was sent to Berlin as art director to organise the design work of the agency. During the same year, Ashley married Margaret Sangster and she accompanied him to Berlin where, as a fluent German speaker, she was able to play an important role. The year in Berlin, 1927–8, was a stimulating one for Ashley and led to further developments in his advertising design. The asymmetric design work of the famous Swiss typographer, Jan Tschichold, who worked in Germany, was having its impact on book design as well as commercial design and printing on the Continent. Later Tschichold became a personal friend.

By 1929 Ashley was beginning to become well known in the world of advertising art (although still only twenty-six). Crawford recognised his value by appointing him art director, and also a director of the company, along with his wife Margaret, Bingy Mills, and Hubert Oughton, an account executive. Ashley had devised for Chrysler a dynamic asymmetric form of layout with bold headlines in capitals arranged in curves, which he had to letter specially for each advertisement [**8**]. His friend, Stanley Morison, was impressed with this style of capital letter and suggested that the Monotype Corporation should cut it as a typeface. This new face was christened Ashley Crawford and its use certainly saved a lot of time in hand lettering for the many advertisements required in different languages throughout Europe. Outside advertising Ashley was continually extending his knowledge and appreciation of wider issues in the world of art, and in particular with new developments in the Modern Movement. This stimulated new friendships and especially with Henry Moore with whom he began to study in 1933 and who remained a lifelong friend. This led to him meeting other artists such as Ben Nicholson and John Piper (see p.83). In 1933 he published his first book, *Line Drawing for Reproduction*. It was commissioned by *The Studio* in 1932, and as Ashley commented later, cost him much hard labour. The book remained popular for a long time, and was reissued in a new, revised and enlarged edition in 1941 and was reprinted in 1945 and 1949. In London in 1934, Ashley met the celebrated German architect, Walter Gropius, who had left Nazi Germany in 1933. Ashley was enormously touched by Gropius's unexpected aware-

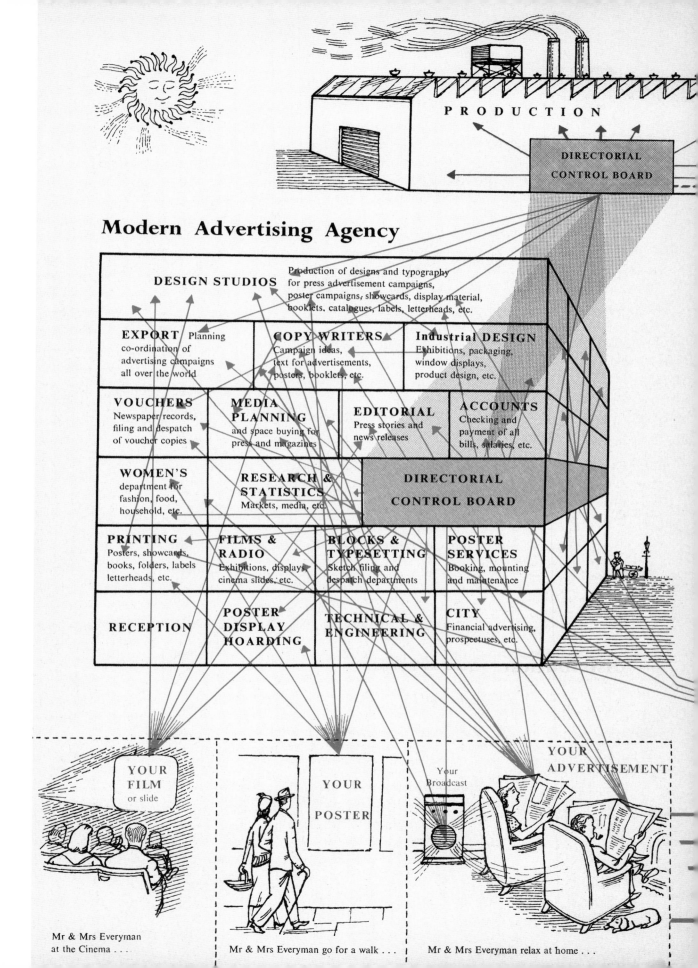

9 This diagrammatic explanation of the role of advertising in the 1950s is surprisingly relevant in the present day. Drawn by Alan Lindsay for the Crawfords brochure.

PRODUCTION

DIRECTORIAL CONTROL BOARD

Modern Advertising Agency

DESIGN STUDIOS Production of designs and typography for press advertisement campaigns, poster campaigns, showcards, display material, booklets, catalogues, labels, letterheads, etc.

EXPORT Planning co-ordination of advertising campaigns all over the world

COPY WRITERS Campaign ideas, text for advertisements, posters, booklets, etc.

Industrial DESIGN Exhibitions, packaging, window displays, product design, etc.

VOUCHERS Newspaper records, filing and despatch of voucher copies

MEDIA PLANNING and space buying for press and magazines

EDITORIAL Press stories and news releases

ACCOUNTS Checking and payment of all bills, salaries, etc.

WOMEN'S department for fashion, food, household, etc.

RESEARCH & STATISTICS Markets, media, etc.

DIRECTORIAL CONTROL BOARD

PRINTING Posters, showcards, books, folders, labels letterheads, etc.

FILMS & RADIO Exhibitions, displays, cinema slides, etc.

BLOCKS & TYPESETTING Sketch filing and despatch departments

POSTER SERVICES Booking, mounting and maintenance

RECEPTION

POSTER DISPLAY HOARDING

TECHNICAL & ENGINEERING

CITY Financial advertising, prospectuses, etc.

YOUR FILM or slide

Mr & Mrs Everyman at the Cinema . . .

YOUR POSTER

Mr & Mrs Everyman go for a walk . . .

Your Broadcast

YOUR ADVERTISEMENT

Mr & Mrs Everyman relax at home . . .

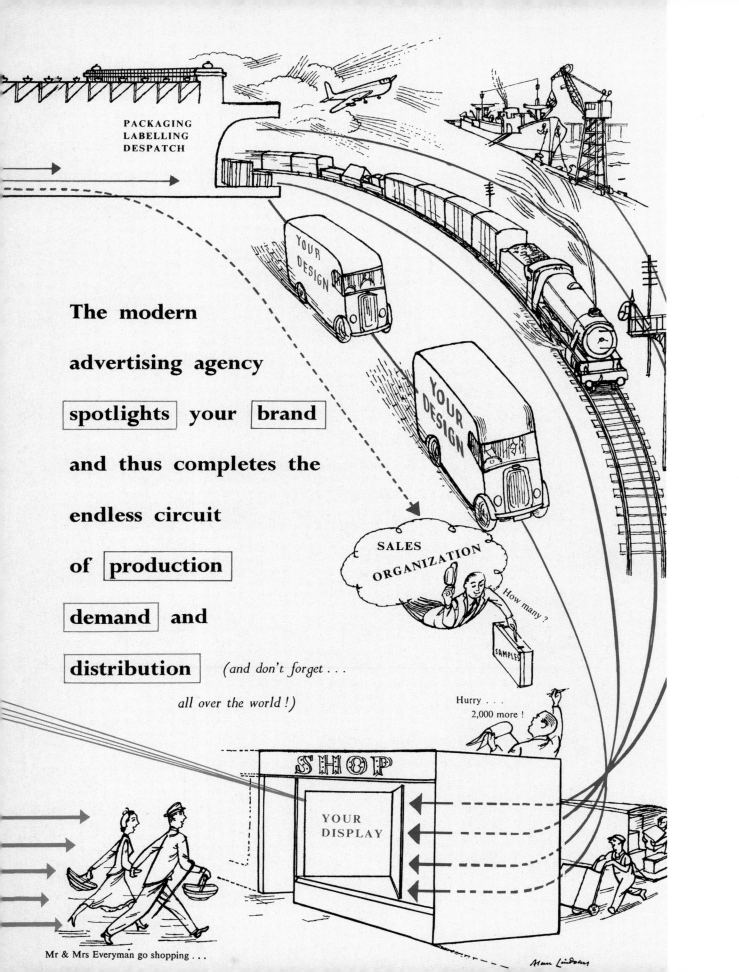

PACKAGING
LABELLING
DESPATCH

YOUR DESIGN

YOUR DESIGN

The modern

advertising agency

spotlights your brand

and thus completes the

endless circuit

of production

demand and

distribution *(and don't forget . . .*

all over the world !)

SALES
ORGANIZATION

How many ?

SAMPLES

Hurry . . .
2,000 more !

SHOP

YOUR
DISPLAY

Mr & Mrs Everyman go shopping . . .

Alan Lindsay

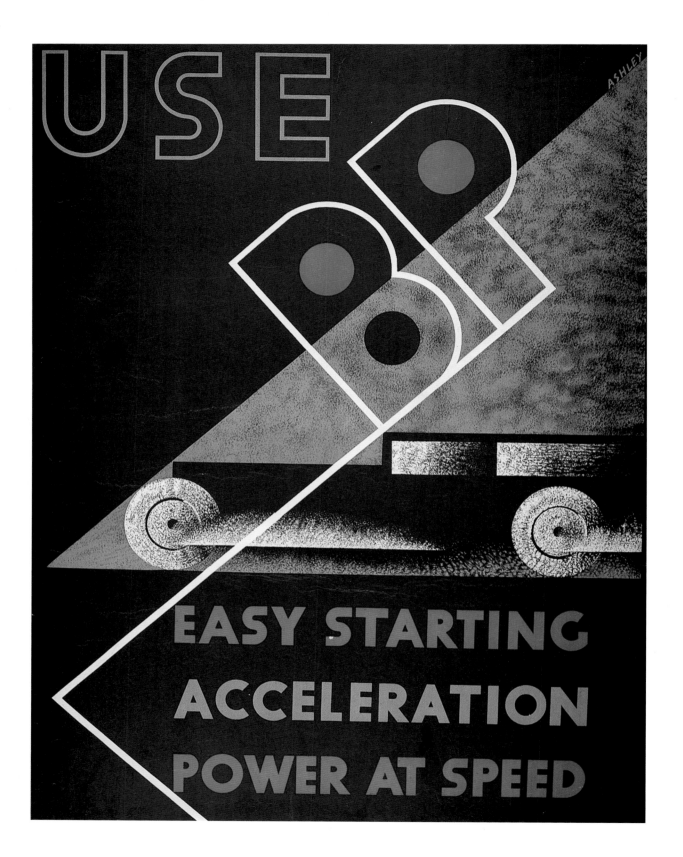

Begin the day with Milk

THE *food* OF FOODS

The food you eat has many parts and functions of your system to nourish and sustain. It has many jobs to do. And there is only one single food in the whole of Nature's storehouse which does them all. It is—Milk!

Milk has the proteins from which your brain and body are built. Milk has the fats and sugars—from which you draw your energy. Milk has the mineral salts—to make for you healthy blood and bones and teeth. Milk has all the vitamins—your 'standing army' against infection.

That is why doctors and dietetians are now saying—if you want to be cheerful, clear-headed, alert and 'full-of-go' throughout the day—lay the foundation of the day with *milk*, the food of foods. Take a cereal with it—take fruit with it—just as you like. But make your breakfast mainly of milk. In a week you will notice the wonderful difference in you. That yawning, that heaviness, that 'tired-already' feeling, will have gone from your days—driven away by the complete *balanced* nourishment in your morning milk!

10 *above* Press advertisement for the Milk Marketing Board, 1936

11 *left* Although British Petroleum, (originally the Anglo-Iranian Oil Company and partly owned by the government) never rivalled the advertising achievement of Shell in the interwar period, they soon learnt how to portray oil products in the visual language of Modernism. In this 1927 poster, the colour range and use of abstract composition is similar to the style associated with McKnight Kauffer, but it includes the unusual characteristic of Ashley's designs of a right-to-left movement.

12 *below* Logo for Simpson Piccadilly, 1936

ness of some of his own design activities. In particular, he referred to his 'Milk' poster, which had only recently appeared on hoardings, and expressed his great delight at the sight of it, congratulating Ashley warmly on the design [**21**]. However, in conversation Ashley said: 'Walter, how marvellous for us that you are now in England, because you can start a much needed Bauhaus in this country.' Sadly, Gropius's reply was 'Ashley, I couldn't do it again.' Gropius was in his fifty-third year, and he was no doubt drained by his experiences in Germany. His star was soon to be in the ascendant again, when in 1937 Harvard University offered him a Chair in Architecture and before departing, Gropius wrote Ashley and Margaret a very affectionate letter of farewell. Other notable friends were László Moholy-Nagy and Herbert Bayer who had been an admirer of Ashley's work. He was much impressed that Bayer also knew about his activities as a British designer. Ashley has written, however, that it was László Moholy-Nagy who probably played the most significant part in his life at this time.

A new development began for Ashley in 1935, when one of Crawfords' clients, Alec Simpson, the dynamic head of S. Simpson Ltd, men's clothing makers, decided to open a new London shop in Piccadilly. Ashley was given the task of designing the brand image [**12**]. Alec Simpson, who lived nearby in Hampstead and had visited the Havindens' house, was very impressed with Ashley's rugs (see p.62), which led to him commissioning a range of rugs to carpet the store. Ashley arranged for Moholy-Nagy to design the displays for the large store windows facing Piccadilly, which was typical of his ready willingness to help others. Moholy, who had only recently arrived in England as a penniless refugee, was paid £2,000 a year for working part-time – a substantial sum in 1936. Ashley commented that Moholy worked happily at the store for some twelve to eighteen months before he left England in 1937 to start a version of the Bauhaus in Chicago.

Ashley's design work extended from rugs to textiles when he was approached by Alastair Morton of Edinburgh Weavers. The new firm, an offshoot of Morton Sundour Fabrics Ltd, wished to produce high quality furnishing fabrics with the intention of raising the standard of design. At this time Ashley's hobby of painting abstract watercolours developed into a serious activity. In 1937 he held his first public exhibition of his work at the London Gallery. At the same time his rugs and textiles were exhibited at the showrooms of Duncan Miller Ltd, the furniture designers.

Much is said later in this book of Ashley's career, but little about what he was like as a person. He was always cheerful, optimistic and remarkably good tempered, and felt that life was to be enjoyed to the full. He was tall (6ft 2in), thin, and dressed elegantly in casual clothes when at home. He loved good food and drink and always smoked a pipe. He was extremely entertaining to be with and had a fund of funny stories, sometimes mildly risqué. His marriage to Margaret was extremely happy and remained so all his life. They lived first in a comfortable house in West Hampstead, where their children, Michael (b.1928) and Venice (b.1931) were born. A two-storey

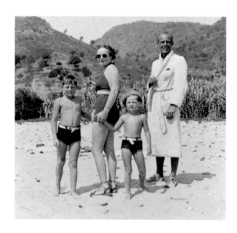

13 Michael, Margaret, Venice and Ashley
Havinden, Aignebelle Plage, Provence, 1937
Private collection

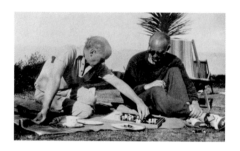

14 Ben Nicholson and Ashley playing chess,
Carbis Bay, St Ives, c.1940
Private collection

wing was added to the house and they decided to furnish it in a contemporary style, which brought them into contact with Madeline and Johnny Duncan Miller. The Havindens stayed at West Hampstead for ten years and in 1938 moved to a dramatic modern flat at Highpoint II in Highgate, London.

Ashley was a very affectionate father and entered with amusement into the family ups and downs, both at school, and in future careers: for example, he always encouraged his daughter, Venice, to paint and arranged for her to study under Fernand Léger in Paris in 1949. Both he and Margaret made a very happy and welcoming home for their children, including their school friends, of whom many came to stay in the holidays. In addition, he had a great talent for living in the present and extracted much enjoyment from all his activities. He loved classic cars, and always drove them rather too fast. Every summer the whole family motored to the south of France for holidays on the beach, often shared with other close friends. As a sportsman he also played tennis and squash very well and acquired a taste, from southern France, for boules, a game that was especially suited to the terrain around the house and yard at Roxford, their third home. This was a Victorian and Queen Anne period farmhouse, in Hertfordshire, to which they moved in April 1949. He also took an interest in Real Tennis at Hatfield House, where he often played with Venice.

Ashley was also extremely hard working, spending many hours leaning over his work table or easel, painting and designing. Our earliest memories of him are at work, and Margaret often complained that he spent too much time at the drawing board. He liked a regular routine, which gave a structure to his life, and this spilled over into the arrangement of his working space. All his equipment was organised in large flat drawers placed at each side of an enormous table that he designed himself. Any borrowing of his tools quickly led to trouble as he was impervious to our childish excuse that he did not seem to need them at the time. Instead, we had to listen to a lecture on the necessity of having one's tools to hand in a designated place. He was meticulous about his work and was not satisfied with any sloppy mistakes, either by himself or others. He often redrew, or painted, whole posters several times if necessary and had endless patience in producing several versions, if required. But he was also good at persuading others which was the best one to choose. His great talent for living in the present, however, rendered him somewhat unaware of the dark clouds that were gathering in Europe at that time, and it was typical of him that, while the family were holidaying on the French Riviera in August 1939, he was completely taken by surprise at the rapidly approaching war, and had to be urged, by Bingy Mills, to return home before it was too late. The family made a dramatic dash through France just in time to catch one of the last ferries from Calais before war was declared. With the outbreak of the war in 1939, as with so many others, Ashley's life was completely altered. In the early days he was soon enrolled in the Highgate Home Guard Battalion, but continued working for Crawfords, designing some posters and ARP and War Loan advertisements for the Ministry of Information.

At the request of Ben Nicholson (whom he had met through Henry Moore), Ashley was instrumental in acquiring sanctuary in this country for Piet Mondrian, who wished to escape the German occupation of Holland. At the same time Ashley received a letter from Nicholson, who had moved with his family to a house in Carbis Bay, near St Ives in Cornwall, in August 1939, asking him to come and stay with them for the summer. The Havindens eventually went to stay in August 1940.

In 1940 Ashley was commissioned as an army camouflage officer. At the age of thirty-eight he found adjustment to army life quite difficult, but struggled conscientiously to master army routine, and the problems of lecturing troops on the principles and practices of camouflage, which was, of course, something quite new at that time. However, life became easier and more interesting for him in 1943, when he was promoted to Captain, and transferred to the Petroleum Warfare Department in London. He worked on the camouflage of the coastal pumping stations of the 'Pluto' project, the pumping of petrol into pipes under the Channel to Normandy after D-Day, to supply the allied tanks and motor vehicles. The camouflage project threatened to be a serious problem, but it was solved by tunnelling into abandoned holiday cottages on the Dungeness coast, and the pumps were erected inside them. Ashley was particularly gratified after the war, when the Germans said they had had no inkling of what was going on.

Ashley began to receive official recognition in a number of different ways. In 1947 he was elected to the Royal Society of Arts Faculty of Royal Designers to Industry (RDI). The faculty is limited to forty members, so that election is a considerable achievement. In 1950 he became a governor of the London College of Printing, a post he held until 1967 and in January 1951, he was awarded an OBE for services to industrial design. This naturally produced a large sheaf of congratulatory letters from a variety of sources. In addition, the trade press was naturally delighted. *The British and Colonial Printer*, 5 January 1951, summed up his standing at that time in an article headed 'Tribute to a Great Designer', noting that the now famous 'Ashley' signature 'is never found except on crisp and unconventional designs,' and that his 'lively and sparkling inventions always appeared just a bit ahead of what was going to be the fashion'. It was not only in advertising, the article continued, but in the design of many outstanding booklets, packages and textiles, for which recognition had now come in the form of his appointment as RDI (Royal Designer to Industry) and as one of the first ten Fellows of the Society of Industrial Artists. It also commented on Ashley as a distinguished painter, whose works were represented in many galleries.

Ashley attended the first annual general meeting of the newly formed Alliance Graphique Internationale (AGI) in Paris in December 1951. It had been formed by a small group of French and Swiss designers, and its first annual general meeting was attended by only nine designers, under the chairmanship of Jean Picart le Doux of France. The other French artists were Jean Colin (general secretary) and Jacques Nathan Garamond (treasurer). Switzerland was represented by Fritz Buhler (vice-

15 AGI Congress in London, 1952. Ashley is third from back on the right hand side of the table.

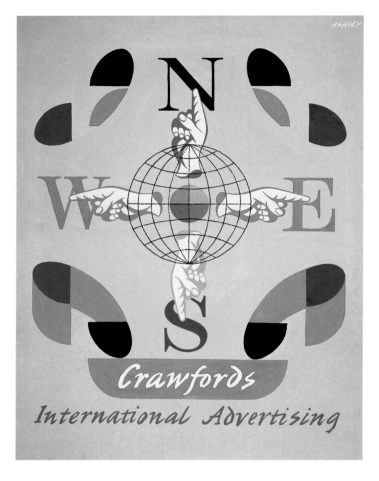

16 *left* The Picasso-like quality of the profile face, produced in the 1950s, combined with abstract forms typical of the 1930s offers one of the most striking of examples of the crossover between Ashley's activities as a collector and practitioner of modern art and his creative work in advertising.

17 *right* Unlike the image on the left, this one, produced in 1957, seems visually confused, with a rather commonplace message and an inappropriately historicist visual language. If nothing else, it shows how Ashley could never be confined to a single formula.

president) and Pierre Monnerat, Britain by Henri Henrion (vice-president) and Ashley, and Sweden by Anders Beckman. Membership was by invitation only and forty-five distinguished artists were invited to join – nine from Britain, twelve from France, four from the Netherlands, five from Sweden, and ten from Switzerland. Contacts were also made with designers in Italy, Germany, USA, Poland and Hungary with a view to their eventual membership, which occurred in due course. Ashley was soon drawn into the AGI's affairs and for the next ten years it took up a great deal of his time and energy, especially between 1957 and 1959 when he was president.

Another aspect of Ashley's life was his role as a fashionable trendsetter in men's clothing. This was illustrated in December 1951 in an article in *The Ambassador*, the British export magazine, entitled 'The Man – the Detail – the Style' in which a dozen well-dressed men were invited to Wheeler's Oyster Bar in Soho, so that the magazine could comment on their clothes. They included the actor, Peter Ustinov; the principal of the Royal College of Art, Robin Darwin; and Norman Hartnell, the well known fashion designer. Of Ashley the article said:

From the men's wear angle he was our first surprise, mostly because he managed to look

far more like a retired military gentleman than any kind of artist at all. His suit was tweed – in fact a country suit and not a town model – although he made a concession to 'fashion' by having a turn-back cuff on the jacket. His waistcoat was warm and woolly looking, beige in colour and conservative in cut. The tie and pocket handkerchief were both of Paisley design, though they did not match. The shirt was flannel in a cream shade with multi-coloured, but widely spaced stripes.

When questioned about his sartorial condition, Ashley said he was dressed 'only for warmth ... I motor up from the country each day, when one does that one dresses for warmth.' Despite this somewhat dismissive comment, Ashley was always very conscious of the need to be at the forefront of men's style, and he took great trouble over his wardrobe, always managing to look elegant and just a little ahead of the coming fashions.

In March 1952 Ashley was invited to exhibit his advertising work with seven other British graphic artists at the National Museum of Fine Arts in Stockholm. The other seven were all friends of his: Milner Gray, Tom Eckersley, George Him, Jan Lewitt, Pat Keely, Henri Henrion and Hans Schleger. The exhibition was opened by the King of Sweden and it gave Ashley the opportunity to study modern Swedish architecture and design, which he had always greatly admired. A touring holiday in Sweden in the summer of 1952 enabled him to carry this even further, and extend his friendship with prominent Swedish designers, such as the poster artist, Anders Beckman, and the ceramic designer, Stig Lindberg.

Also that year, an important and well-illustrated article by Charles Rosner on Ashley and his work was published in the influential Swiss applied art magazine *Graphis* showing how Ashley's reputation was spreading on the Continent. The article contains twenty-eight illustrations of advertisements almost all of which were by Ashley. In 1953 he was honoured to be elected president of the Society of Industrial Artists (now the Chartered Society of Designers), an influential design organisation of which he had long been a member. This office involved him in committee work. The AGI also continued to occupy his time, and in 1953 he attended its third annual general meeting in Paris, at which it was decided to hold a major exhibition of members' work at the Louvre, Paris in 1955.

Ashley read a paper to the Scottish Design Congress, held in Edinburgh on 26 and 27 May 1954, under the auspices of the Scottish Committee of the Council of Industrial Design. His paper was called 'Designer for Industry', and reflected the fact that after World War Two Crawfords had established a subsidiary company for industrial design called Sir William Crawford and Partners of which Ashley was chairman. However, the label of industrial design may be slightly misleading, since the company concentrated more on packaging, logos, trademarks and publicity than on the design of machines and manufactured products. Ashley concentrated on that aspect in his talk, stressing the need for companies to have an overall design policy, which integrates their varied products, and presents an attractive face to their customers. He, of

18 Ashley in his studio at Crawfords, c.1955

AEGKNQRS

Ashley Crawford typeface

AEGKNQRS

Ashley Script typeface

19 Henry Moore playing boules at Roxford,
c.1960

course, had achieved considerable success with this type of approach in his work for some of Crawfords most important clients, like Simpson and Liberty, and he thought it could be equally well applied to industrial products.

In 1955 the Monotype Corporation brought out the Ashley Script in upper and lower case letters in five different sizes. This was based on the free brush lettering originally evolved by Ashley in 1936. Ashley's second book, *Advertising and the Artist* was published in 1956. The book contains an enthusiastic introduction by Sir Stephen Tallents. He was an influential former civil servant, who had played an important role in encouraging higher standards in advertising when in the following posts: secretary to the Empire Marketing Board (1926–33); public relations officer at the General Post Office (1933–5); and controller of public relations at the BBC (1935–40). In his introduction, Tallents noted that, with characteristic modesty, Ashley had been too reticent about his own work; the only serious omission in it. At the end of the book Ashley set forth his belief that artists could raise the standard of advertising, and in so doing, could also have a powerful influence in raising the general level of public taste. Of course, since these words were written the balance of advertising has swung dramatically from posters and press advertisements to television.

In 1960 the importance of Ashley's role at Crawfords was underlined by his election to the vice-chairmanship, a position he held until his retirement in 1967. He continued to travel widely, partly on Crawfords' behalf, and partly for recreation. In July he and Margaret went on an extended trip to Canada and New York. In Toronto they attended a Canadian Advertising Congress and had an opportunity to study Canadian commercial art and design, which they found impressive. Later they flew to New York and visited some of Crawfords' American clients. Their extensive travelling continued in 1961, when they visited Pakistan, India, Malaya, and Singapore. This trip originated with a visit to Karachi to the head offices of Pakistan International Airlines, an important Crawfords' client for whom Ashley produced some striking posters. It also enabled them to visit their daughter, Venice Lamb, whose husband, Alastair, was teaching history at the University of Malaya in Kuala Lumpur. Trips to Bangkok and Singapore also gave Ashley a chance to evaluate the prospects in the emerging south-east Asian markets, which were beginning to make an impact on the world economy.

Ashley and Margaret attended the Manchester Regional College of Art's graduation day, in July 1961, where he was awarded an Honorary Doctorate of Arts. This recognition by an art college must have been gratifying for someone who was almost entirely self-taught, and he was always much in demand as an assessor of work at various art colleges. In 1962, Paul Peter Piech, the vice-chairman of the Society of Typographic Designers (of which Sir Francis Meynell was president), wrote to say: 'we have voted you a Fellowship in the Society of Typographic Designers, which we would be very pleased if you would accept.' Naturally, Ashley was delighted to accept this honour.

A particularly difficult time came for Ashley in 1962 when Margaret retired from Crawfords after a long and distinguished career during which she had been of inestima-

20 Ashley and Margaret Havinden in the studio at Roxford, designed by Maxwell Fry, c.1961.

ble help to Ashley in all his endeavours. The absence of Margaret at work was a major blow to Ashley and he greatly missed her support in an increasingly difficult and competitive world. The structure of Crawfords had changed over the years, and younger more thrusting men wanted to take over, causing Ashley to feel threatened and less appreciated at work, in spite of his reputation worldwide.

Ashley's advertising work was again exhibited in 1964 at the AGI exhibitions in Hamburg and New York. His involvement in art education also grew when in October 1964 the executive secretary of the Society of Industrial Artists and Designers wrote to thank him for accepting the society's nomination as a governor of Chelsea School of Art.

In 1967 Ashley took the momentous decision to retire from Crawfords, slightly early (he was sixty-four), in order to devote more time to painting and his private design commissions. When the news was announced he received many letters of appreciation for his long service to Crawfords. The date of retirement was 31 May 1967, and the faculty of the RDI took the opportunity to elect Ashley their Master, a post which he held until 1969. It was a signal honour and involved Ashley in a great deal of committee work, which no doubt helped him to ease the adjustment from his busy life at Crawfords to retirement. However, he was always happiest painting, especially in his delightful new studio at Roxford. His involvement with the AGI also continued and he and Margaret attended the Nice congress in 1967. In 1970 Ashley became involved in the project of writing a prologue to Michael Frostick's book, *Advertising and the Motor-car*, in which he recorded his early experiences at Crawfords. This project involved a visit to the archive at the Beaulieu Motor Museum to consult Lord Montagu. As Ashley had always been a keen motorist the project and visit were very enjoyable for him.

One of the last items in Ashley's correspondence file is a card from John Piper showing an abstract design which Piper produced for Chichester Cathedral. This was in reply to a letter of congratulation from Ashley on the occasion of Piper's appointment as a Companion of Honour. Piper also expressed the hope that they would all soon meet again. It was not to be, as Ashley died quite unexpectedly on 31 May 1973 from a heart attack following successful surgery. Characteristically it was while enjoying a joke with his surgeon that the fatal attack occurred. Margaret, after a long illness, died in 1974.

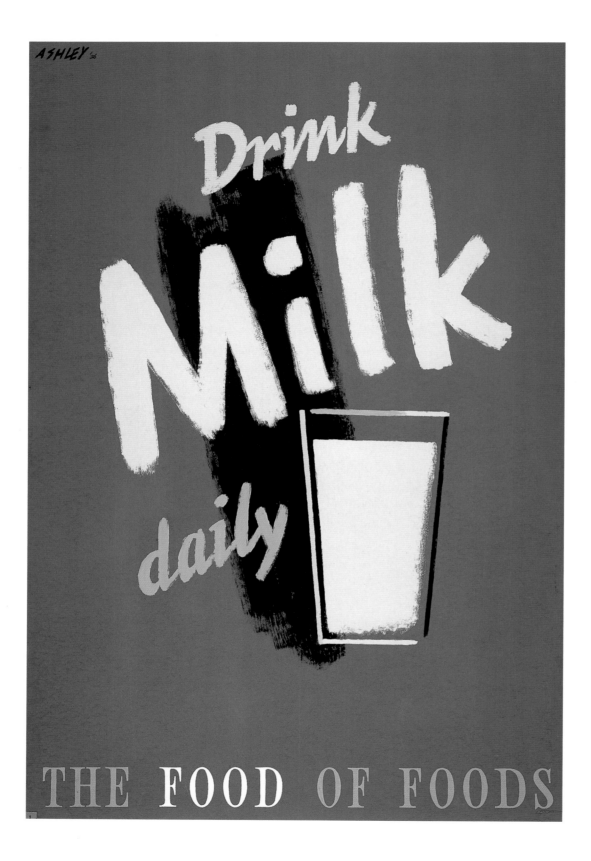

21 Ashley's mastery of the brush for illustration and lettering integrates the message in a single graphic style. Writing of his 1936 Milk Marketing Board poster, he later commented, 'The more humanistic rough brush technique, although functionally evocative of the fluidity of milk, was indicative of a break-away from the mechanical geometric display of letters of the early twenties and thirties.' The Milk Marketing Board was established in 1935, a year before this poster, and spent £60,000 per year advertising through Crawfords, using Ashley's distinctive lettering.

ASHLEY HAVINDEN
ADVERTISING AND ART

Richard Hollis

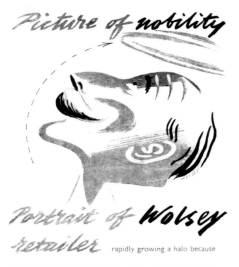

22 The profile of the Wolsey retailer could easily be seen as a self-portrait of the postwar Ashley.

Advertising is a huge industry. Its products surround us: in the streets, on public transport, alongside what we are reading in newspapers and magazines and now most commonly on television. But we know little about its workings or those who earn their living in advertising. It has few celebrities, few public faces. It creates stereotypes. Ashley Havinden developed into a stereotype. From the 1940s onwards he adopted a military moustache, dressed in tweeds and looked like a country gentleman [**3**]. However, this was a misleading image. He was an artist. But he was an artist who worked in advertising, and his working life, from the 1920s to the 1970s, was spent in an effort to reconcile the aesthetic and the commercial.

As an artist, Ashley's identity was made with the brush. Not surprising that he described the corporate identity of an enterprise or organisation as 'the handwriting of the firm'. His own brushed lettering is the 'handwriting' of the man: confident, elegant, good-humoured, like the male figures he drew for advertisements. But Ashley used his brush not only to make commercial art, but also to make pictures to be hung in galleries.

There were only loose connections between 'commercial art' and 'fine art'. Where they existed, the link was the artist, with one foot in popular culture and the other in 'high' art. During Ashley's time artists borrowed from advertising (Fernand Léger, Stuart Davis, for example). But, in the other direction, many commercial practitioners, especially poster artists, took their style from painters. There was a moment for Ashley, in the mid-1930s, when the 'high' and the 'low' coincided.

ADVERTISING AGENCIES AND CRAWFORDS' PRACTICE

Ashley arrived at Crawfords' advertising agency as a trainee layout artist in 1922. Founded in 1914 by William Crawford it was already one of the largest advertising agencies in Britain. The chief job of agencies was to buy advertising space for clients.

23 *above* In 1920, two years before Ashley
joined the firm, Crawfords advertised itself in a
typographic style hardly different from the
newspapers and magazines in which the agency
bought space for its clients.

24 *opposite above* The layout of this 1926 adver-
tisement is still traditional in its symmetry, but
the narrow columns of newspaper typesetting
are now easier to read when laid out according
to the new standards set by such typographic
reformers as Stanley Morison.

25 *opposite below* For the early Chrysler cam-
paigns Ashley drew the cars and figures in the
style of engravings – modern but without the
extreme formalisation of the later advertise-
ments. His hand-drawn lettering was the basis
for the typeface known as Ashley Crawford.

Their income was the commission paid to them by the newspapers or owners of
billboard sites. In 1925, a senior advertising man, Sir Charles Higham, described the
agency as an organisation that

*buys newspaper space on advantageous terms; writes, illustrates and prepares advertise-
ments … securing the services of the best copywriters, poster artists and designers …
designs trademarks, cartons, wrapping paper, labels … A good agency knows every-
thing about the cost, tone and circulation of every paper that is published … It compiles,
writes and illustrates catalogues, leaflets, booklets and house organs; designs posters,
understands the technique of typography, blockmaking, lettering, colour printing and all
engraving processes.*[1]

Words and images make up the advertising message. They have to be put into a
printable form, and appear in the right place at an appropriate size. These needs
determined the agency structure. Split into copywriters, layout artists, illustrators and
photographers, account executives (responsible for the advertising of a group of
clients) and supporting staff, the groups were not always co-operative. Ashley's copy-
writer was 'Bingy' Saxon Mills. Ashley had found him a place at Crawfords, and
Ashley's future wife, Margaret Sangster, as account executive, formed the third
member of a 'unique creative cell'. When Ashley arrived at Crawfords he remarked:

*I was soon put in the studio on the 'layout' staff. This was most interesting as it involved
arranging all the elements in a given advertisement to fit the dimensions of the space
booked in a newspaper … Layout work involved deciding the size and style of the
lettering (or typeface) of the main headline, and co-ordinating this with the position and
size of the illustration together with the main text matter (copy), not forgetting the
nameblock … which had to be displayed at the bottom of the advertisement. Frequently
the firm's 'slogan' also had to be displayed under the 'awful' nameblock.*[2]

According to the 1930s thriller by Dorothy L. Sayers, *Murder Must Advertise*, a new
employee would find that the aim of the studio artist was 'to crowd the copy out of
the advertisement'. The copywriter's ambition was 'to cram the space with verbiage'
and leave no room for the illustration. The layout man 'spent a wretched life trying to
reconcile these opposing parties'.[3] *Murder Must Advertise* gives a clear and colourful
idea of everyday work in advertising at that time. Dorothy L. Sayers, once an agency
copywriter, locates the book's fictional agency only a few hundred yards from
Crawfords' address. It is almost next door to Holborn Underground station, where
they moved in 1921, to a building whose refurbishment in stainless steel and black
marble made it a famous example of modernist architectural design.[4]

Crawford attracted 'West End clients', and the social columns in the newspapers of
the day recorded the attendance at his dinner parties of literary notables such as
Rudyard Kipling and Hilaire Belloc. He took his profession seriously. Determined to
improve it, he twice crossed the Atlantic to study American practice. In Britain, the
depressingly low standard of advertisements had been taken in hand by a competitor
from Manchester, Charles W. Hobson. With brilliant copywriting and layouts by one

of Britain's most distinguished academic typographers, Stanley Morison, Hobson's agency set a new example. According to Ashley, at a chance meeting, Morison persuaded him of the need to improve advertising typography and fired him with an enthusiasm for the work of the poster artist, Edward McKnight Kauffer.[5] Morison advised the Monotype Corporation on the design of typefaces for their composing machines; his own typography, interrupted by occasional ventures into asymmetry and the use of sans serif type, reworked traditional methods.

The visual side of making advertisements comprised making layouts and drawing illustrations. Layouts meant typography, which had attracted intelligent interest in England since the intervention of William Morris in the 1870s. The Monotype Corporation had redesigned good, old typefaces that were slowly replacing the spidery preferences of the Victorians. Although these were designed for machine composition, since each letter was an individual piece of metal, they could be typeset by hand, and very refined typography could be achieved. The printing of advertisements was an elaborate process. When the same design was to appear in several newspapers, the production department of the agency would have been obliged to make adaptations of a master layout to fit various shapes and sizes of the spaces bought in them. The type style specified by an agency layout man might not be available at the newspaper, so then it would be only the nearest approximation. The results were, at best, uneven. Ashley proposed that Crawfords should follow the lead given by Hobson: they should have their advertisements typeset before they went to the newspaper. This could be achieved by making a moulded facsimile of the typeset copy. Each appearance of the advertisement would then have headline and copy with consistent typeface, size and spacing.

Morison's influence, and the sober typography of upmarket American advertisements, is obvious in Ashley's designs for the Pennsylvania Hotel New York [24]. He was happy to have these designs reproduced in the following decades, with their symmetrical layout and type set in three magazine-like columns. Their style is traditional, whereas Ashley's evident emulation of McKnight Kauffer in his Chrysler advertising is dramatically modern. The stylised, angular silhouettes of the figures, also used in the Eno's Fruit Salt poster, were a contemporary mannerism [25]. So too were the abstract streamlines of the black and white press advertisements for Chrysler [29]. These advertisements were important in establishing Crawfords as an agency using a progressive commercial style.

ART, COMMERCIAL ART AND MODERNISM

It was unusual for a commercial artist, one who aspired to draw posters, not to have trained at art school. 'In most cases', wrote Herbert Read, 'the commercial artist has had a training directed to higher things. The "Fine Arts" have been represented as a heaven to which he should aspire; the "Industrial Arts" as a purgatory with which he might have to be satisfied.'[6] Those who had been to art school were most likely to have

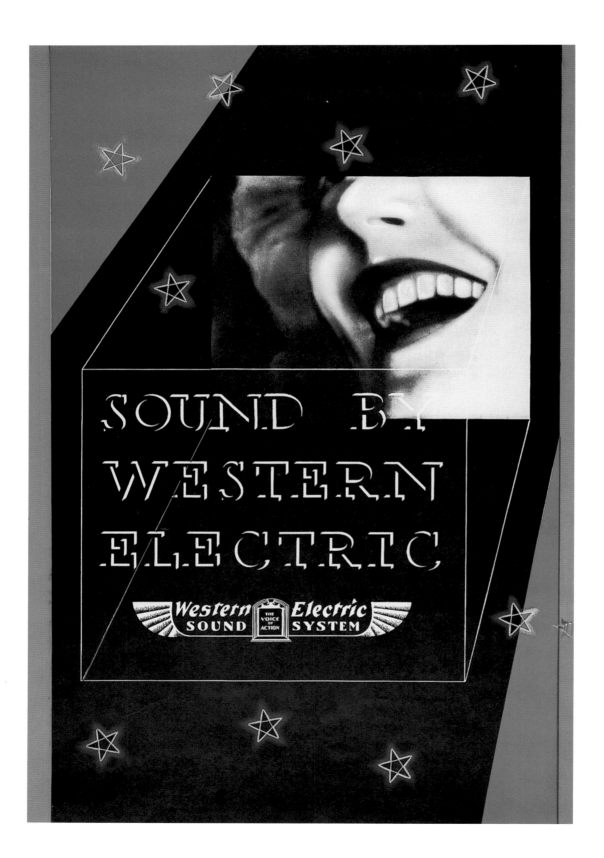

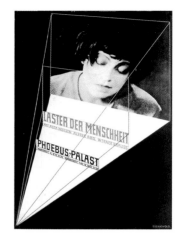

26 *left and above* In this 1929 design to advertise a cinema sound system Ashley approached the graphic representation of film in a similar manner to Jan Tschichold's poster for a Munich cinema two years earlier. In 1936 Tschichold contributed to the English constructivist anthology *Circle*, which included several of Ashley's artist and architect colleagues.

27 *opposite* The full range of 1920s commercial techniques are deployed for Dewar's. Its art deco shading is French in inspiration, whereas the cloud shapes, which are naturally produced by the airbrush technique, become a favourite motif of Ashley's. In 1929 the inclusion of the bottle by photomontage was avant-garde. The lettering at the bottom, an extension of Ashley's signature, is a forerunner of his famous script.

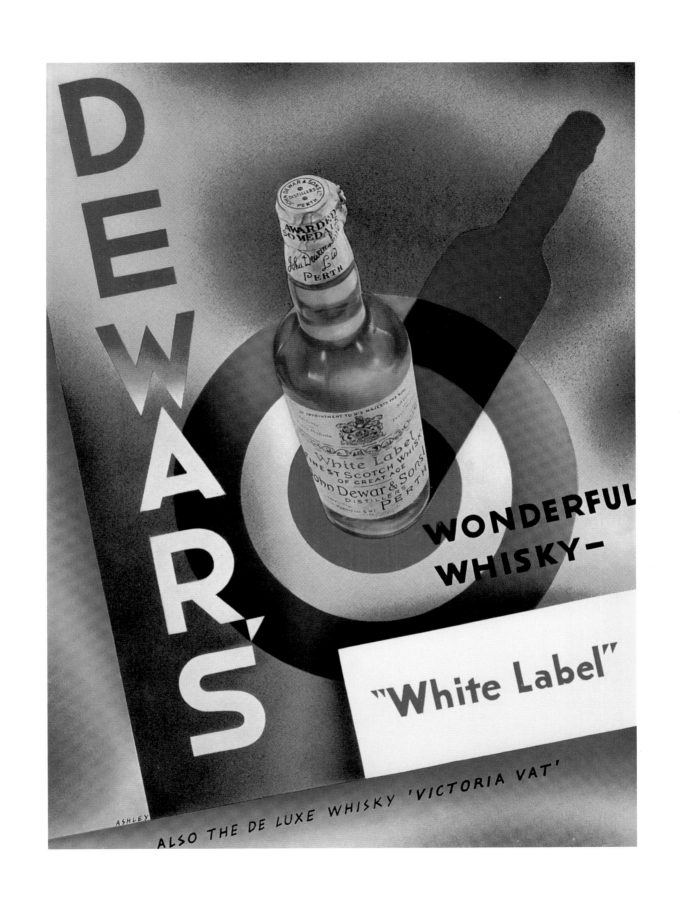

28 Illustrating its reach to markets in thirty countries with twenty-three different languages, Crawfords in Berlin added headlines in Russian, Greek, Hebrew and Czech to Ashley's earlier woodcut- style drawings for Chrysler.

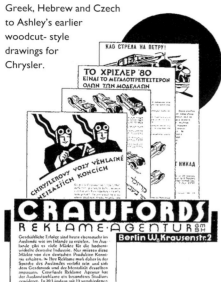

29 *right* Ashley's abstract simplification of the car was repeated in a series of advertisements. From the wordy lines of 'copy', a visual image has been selected to illustrate one of the car's functional selling points.

The fashionable diagonal layout in this 1928 press advertisement has exploited literally the 'steepest roads' found (or inserted) in this copy. Ashley brilliantly manages the photo-engravers technique of breaking up the solid black to give a half-tone grey.

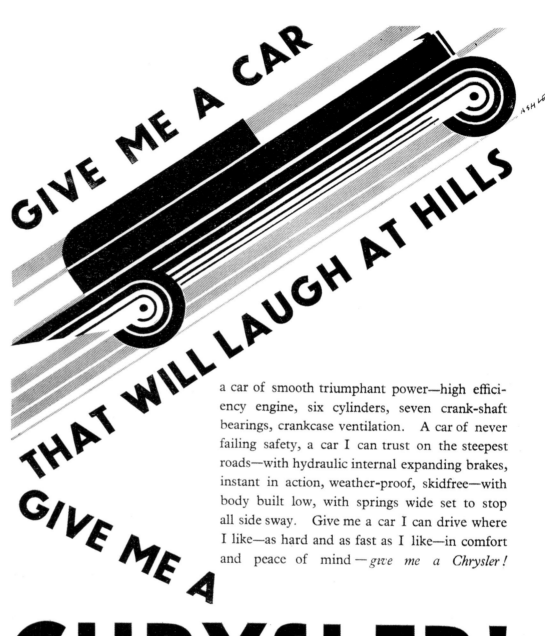

GIVE ME A CAR THAT WILL LAUGH AT HILLS GIVE ME A

a car of smooth triumphant power—high efficiency engine, six cylinders, seven crank-shaft bearings, crankcase ventilation. A car of never failing safety, a car I can trust on the steepest roads—with hydraulic internal expanding brakes, instant in action, weather-proof, skidfree—with body built low, with springs wide set to stop all side sway. Give me a car I can drive where I like—as hard and as fast as I like—in comfort and peace of mind—*give me a Chrysler!*

CHRYSLER!

Three great 6-cylinder ranges—Chrysler Imperial 80 from £940, Chrysler 75 from £515, Chrysler 65 from £375! Chrysler cars of every type and price. See all the models in the dealer's showrooms.

WRITE FOR CATALOGUES · CHRYSLER MOTORS LTD · KEW GARDENS · SURREY

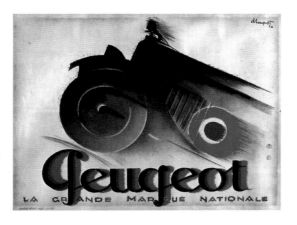

30 *above* The graphic evocation of speed was a challenge for all commercial artists in the 1920s. The diagonal arrangement and the suggestion of slipstream were always part of the image. The French poster artist, Charles Loupot, employed the angle and slipstream for Peugeot in 1926.

31 *below* The following year, the Swiss artist, Eric de Coulon, based in Paris, gave this innovation a more abstract geometry. This has most of the ingredients of Crawfords' Chrysler advertisements and was further stylised by Ashley in 1929 for the Chrysler catalogue.

had ambitions as painters. Some who worked in advertising went to the art schools for a day or half-day each week, or to evening classes. Ashley trained as he worked: not at first in advertising, but at a large printing firm on the outskirts of London. In this way he understood the techniques of reproducing text and images before he had the opportunity to use them for his own designs. Ashley had an advantage in the world of advertising by not going to art school. Besides, academic proficiency was not his aim. When he began at Crawfords his intention was to produce good advertising, which needed a striking idea presented with style. Ashley brilliantly exploited the repertoire of debased Cubism for the Chrysler advertisements. He was not aiming to make commercialised art. This was to come later when aspects of abstract painting suggested formal arrangements and techniques that could be exploited by the layout men.

In 1926 William Crawford and Ashley took off on a fortnight's fact-finding tour of Germany. Crawford knew the country and spoke the language. Together they visited a number of type foundries. They were welcomed in the offices of *Gebrauchsgraphik*, the new magazine for commercial art. Each issue of *Gebrauchsgraphik* was anxiously awaited in studios across Europe and in the United States: the styles and ideas in its pages quickly appropriated and adapted for whatever the smarter agencies had in hand. In Berlin, Crawford and Ashley called on the type designer and poster artist, Lucian Bernhard, and the packaging specialist, Otto Hadank. Although Ashley talked later of the typographic revolutions of the Bauhaus, they visited only designers who had made their names before the First World War. The report made on their return says that in Munich they visited the most celebrated, namely Ludwig Hohlwein and Julius Engelhard.[7] Munich at this time was a centre of the best traditions of German graphic design, but also of the most progressive and modernist. The typographer Paul Renner, in charge of one of the printing schools, was designing Futura, the famous geometric typeface. His fellow teacher, Jan Tschichold, the leading theorist and practitioner of the New Typography, would introduce Modernism to England in the pages of the monthly *Commercial Art*: this only four years later.

The styles of commercial art ran parallel to fine art. They were rarely a direct imitation. Poster artists, in particular from Germany, had restricted their colours and tones to plain, flat shapes. And Cubism's revolution in picture-making provided the commercial artist and the advertisers with a means to make modern, simplified images, not merely of their products, but also as illustrations. Gone were traditional perspective, realistic tone and colour. Morison had suggested that Ashley might emulate a showcard designed by McKnight Kauffer for a dry-cleaning firm. We do not know which design it was and, since Kauffer produced cards in quite different styles for Eastmans around this time, it is hard to know how Ashley followed the advice. Certainly the Eno's Fruit Salt poster with three horsemen has the same kind of lettering as Kauffer drew, so has 'Spreading Everywhere' in Ashley's 1929 poster for St Martin's jam. The typeface could as easily derive from a Bavarian brewery poster,

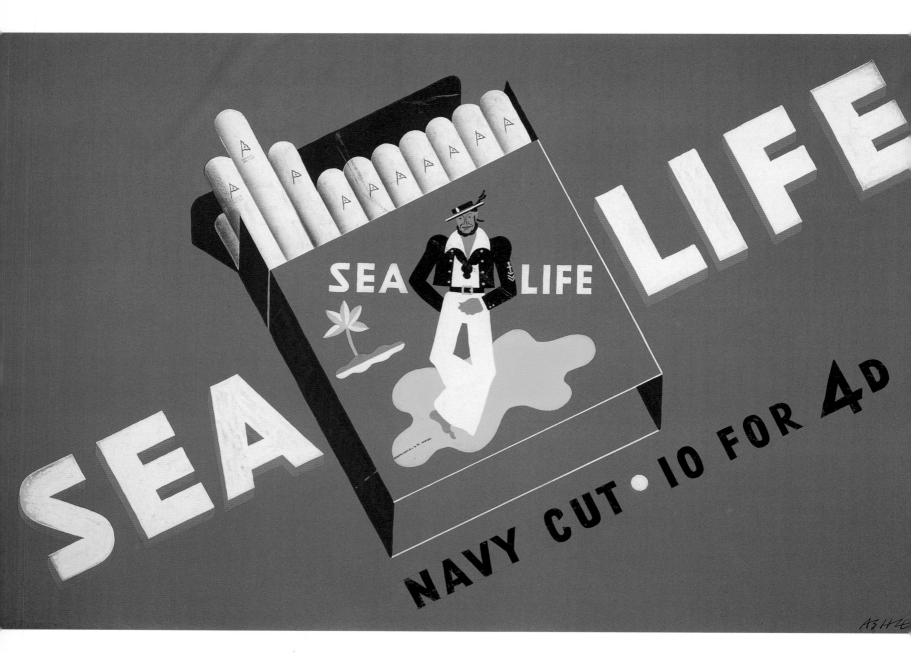

32 *left* One of Ashley's few purely modern and most successful designs. Here the horizontal lettering anchors the diagonals, and Ashley's much-repeated cloud shape serves as a sandy island on the packet. Ashley's speculative 1930s poster brought a tradition up to date. Smoking was associated with sailors (Players Navy Cut was a leading brand for decades).

33 *right* A writer in the magazine *Commercial Art* in 1928 commended the boldness of this 1927 poster for its time: 'In many quarters in England it is still held that modernity in art is either wicked or weak-minded, and is in any case a ruinous attribute. At least one is often told this is so though I have never personally witnessed a popular outburst of indignation in front of Mr Ashley Havinden's Eno's Fruit Salt poster.'

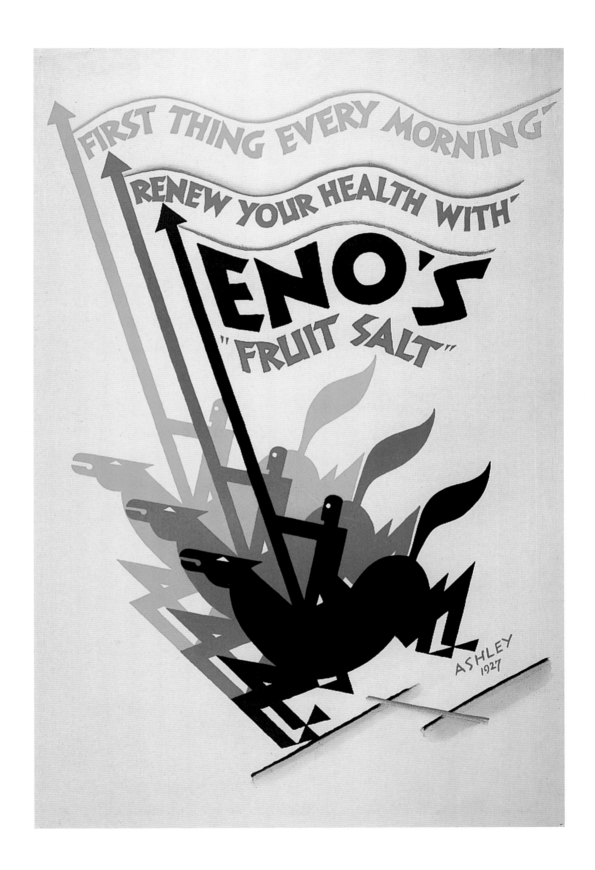

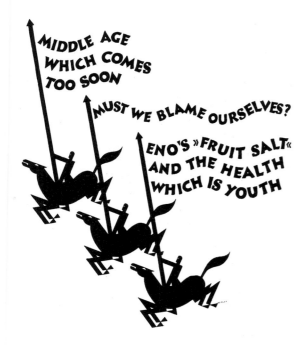

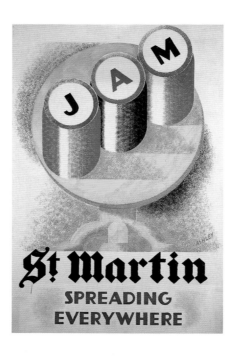

while the illustration was as much French in inspiration as much of Kauffer's work [**34 & 35**]. The style of each job was not personal to Ashley. It was a variation on an existing style. The most original feature of his early work was the brushed Ashley signature. The signature on a poster is followed by the year, as on a painting, and Ashley signed his work throughout his careeer, even press advertisements.

Meanwhile Ashley's art was commercial. Of the Chrysler campaign, which began in 1925, Ashley claimed that 'at the time this new, bold and asymmetric approach to the designing of motor-car advertisements (echoing the original Bauhaus Moholy-Nagy influence of 1923) was a landmark in British advertising'.[8] It was certainly a landmark, but it had nothing to do with Moholy-Nagy. Indeed, Ashley confessed late in life, that at the time he had 'only a vague idea' of what New Typography was all about. He explained:

Our aim was to produce a new kind of dynamic effect which, with the major elements in the advertisements placed at angles, would stand out in the press by reason of bold 'contrast in weight' (i.e. degree of blackness) and especially by contrast to the normal appearance of the vertical columns, with horizontal text and headlines, in the rest of the pages, whether in newspapers or magazines. We also got rid of the 'nameblock' at the base; we felt that the advertisement should be designed as a whole. The composition, like a constructivist painting, should be asymmetrically balanced in every detail, the bottom of the advertisement playing its part in the total composition just as much as the top, thus integrating the product with the rest of the display.[9]

The fact that Ashley mentions a 'set it crooked' school implies that Crawfords was not alone in using the diagonal. It was indeed a feature of constructivist graphics, but it was also used by German Expressionists and Parisian *affichistes*. It is surprising that Ashley left no record of his time in 1927 and 1928 when he was helping to organise Crawfords' Berlin office. It was a moment of cultural and political excitement, the high point of the Weimar Republic before the world economic crisis and the Hitler regime. The Modern Movement in architecture was firmly established and the New Typography had taken root. There is no evidence in Ashley's work that he was aware of the Modern Movement until the mid-1930s, whereas McKnight Kauffer's social circle included many of the intellectuals of the time. Kauffer had a flat in the same house in Holborn as Leonard and Virginia Woolf's Hogarth Press and was friendly

with the translator of Le Corbusier's book *Vers une architecture*, the architect, Frederick Etchells, who rebuilt Crawfords' offices. Before Ashley met Henry Moore at a private view of the sculptor's work in 1933 he says that he had never met a fine artist. Yet he knew Wells Coates, the Canadian émigré architect, who pioneered the undecorated concrete International Style with a block of flats in Hampstead. The Havindens, living in West Hampstead, and later in the Highpoint II flats (another modernist landmark), were close to avant-garde activity, especially with the arrival from the Continent of refugee artists, architects and designers. Walter Gropius arrived in 1934, László Moholy-Nagy and Naum Gabo in 1935 and Mondrian, the following year. When Mrs Noel Norton, a former Crawfords' copywriter, opened the London Gallery, dedicated to abstract and constructivist work, Ashley designed the stationery and exhibition invitations.

By the mid-1930s Ashley's personal brush handwriting reached its pitch of economical perfection in the 'Milk' and 'Beer is Best' advertising [**40**]. The year 1937 was Ashley's annus mirabilis (see p.82). His work was published in a British advertising issue of *Gebrauchsgraphik* and the poet and critic, Herbert Read, wrote an article about him for the magazine *Typography*.[10] Read led much of the discussion on art, applied art, and the design of manufactured goods — a debate that had continued since William Morris expressed his concerns in the 1870s. With the aim to reconcile aesthetic and commercial interests, the Design and Industries Association had been founded in 1915 and the Society of Industrial Artists in 1930. The issues were put to

36 *left* Bent over the near-vertical drawing board, brush in hand, Ashley is the image of the artist. Like the painter, he would sign his work. But the commercial artist was not making a unique object, but one that would be reproduced, often in thousands, and in more than one size. Ashley's 'Milk' poster was enlarged to over two metres high.

37 *right* Photographs, which 'never lie', authenticate the slogan of newspaper advertisements c.1938.

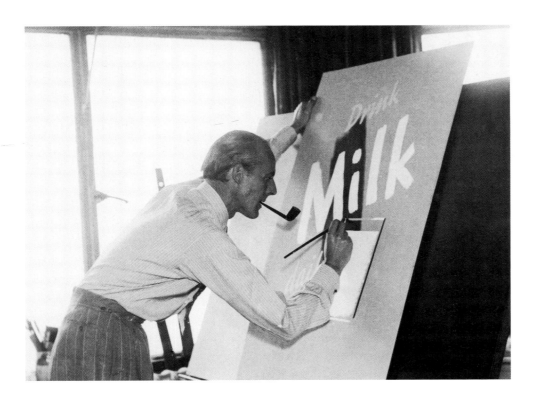

makes for loveliness

The woman who does not drink plenty of milk — denies herself Nature's finest beautifier. Milk has in it everything your looks and well-being need. Milk is a complete beauty diet in itself. It contains the perfect proteins — for building without fattening. It contains lactose, the perfect sugar — for sparkle and vitality It contains the mineral salts, which preserve your nice white teeth — the vitamins which guard you against infection. Milk is a complete food and a balanced food — neither lacking nor exceeding in any virtuous element. Begin the day with milk, end the day with milk — and no beauty treatment ever devised by man could do more for you!

the public in radio debates and exhibitions. In his book, *Art and Industry*, Read had asserted that utilitarian objects appealed to the aesthetic sense as 'abstract art'.[11] He claimed that typography was an abstract art. But the difficulty was that advertising was 'anything but abstract'. Writing about Ashley, he said:

I am not sure that the main interest of the arts of publicity does not arise directly from this fact: that in these arts the humanistic and abstract elements are inevitably combined. However contradictory such elements may be, in the best (best in the sense of most effective) type of publicity-art they must be resolved in some kind of synthesis.[12]

Read continued with useful critical remarks:

If we make a direct analysis of Ashley's work we find that its popular appeal is due to various factors which we may formulate as:

simplicity; typographical technique; humanity; wit; surprise.

These factors are not so distinct and independent as a list of them makes them seem; they are, indeed, completely unified, and it impossible to say whether the element of surprise – the 'eye wonder' which is the essential quality of a good poster or display advertisement – is due to the 'idea', the expression of the idea, or the typographical display of the whole conception.[13]

Read says that 'a bright idea' is essential. Citing several of Ashley's campaigns, even his drawings of 'old colonel' stereotypes, Read claims that such figurative elements 'become as formal as a figure in a carpet – elements in a constructive pattern, a prison of lines and spaces from which they would only escape to perish'. Here Read's use of the word 'constructive' is very deliberate. The year 1937 saw the publication of *Circle: International Survey of Constructive Art*. The book is divided into four sections: painting, sculpture, architecture and art and life. In the last section, there is a short article on 'New Typography' by Jan Tschichold: 'The real value of the new typography,' he wrote, 'consists in its efforts towards purification and towards simplicity and clarity of means.' Tschichold concluded with a summary of 'New Traditionalism' and 'New Typography'. Neither is given preference: they share the disappearance of ornament and the significant difference is that one is symmetrical, the other is 'organisation without a middle point (asymmetry)'.

THE CAMPAIGNS

Many of Crawfords' clients stayed with them for more than a decade – some for half a century. Eno's Fruit Salt, a powdered laxative, was still using Crawfords in the mid-1960s. The early Eno's advertisements show how quickly Ashley developed. In his much-reproduced early poster, the three knights on horseback are more arresting and memorable than the elaborate slogan [33]. There is a sensitive graphic connection – the solid weight of the letters matches the riders' silhouettes. But the image and the words carry separate meanings. The press advertisement is even more confusing. As the Eno's advertising developed, its words and images combined to give the message. Although the theme is still the fear of middle age, the drawing is a direct, eye-

Wolsey

CARDINAL SOCKS

are re-inforced with nylon at heels and toes; and are guaranteed not to shrink!

a boon to men – and women !

38 Ashley establishes the brand's 'handwriting' with a graphic style not only for the Wolsey logo, but in the arresting wit of a series of comic drawings.

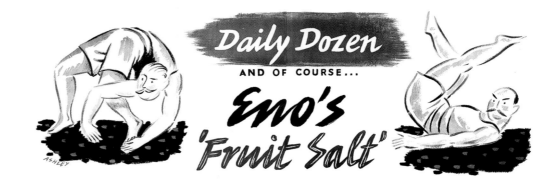

catching and amusing illustration of the headline, 'Daily Dozen' [**39**]. Moreover, there is a visual link: words and image are made with the same tool, the same graphic mark.

Promoting cars and their fuel produced much of the liveliest publicity of the inter-war years. Ashley was a passionate motorist with an interest in the style and performance of a vehicle. As a young man at Crawfords he drove a Bentley and after the war he drove to meetings on the Continent in a Rolls Royce Silver Ghost. Yet the style of the first Chrysler advertisements, embellished with the same woodcut-like figures and naive drawings, was little different from those for Eno's. The full art deco treatment soon took over.

If Ashley later invoked the avant-garde influences of fine art, the inspiration for the advertisements' graphic impression of speed and the mechanical illustration of the car is more likely to have been the work of foreign poster artists. In Paris, Charles Loupot painted the design for the poster for Peugeot in 1926 [**30**]. A year later, the motor race poster by the Swiss artist, Eric de Coulon [**31**] had most of the ingredients of Crawfords' Chrysler advertisements. Ashley's skill was in simplification, placing tonal rendering in a form suited to press advertising. The range of tone in a photograph, from white, light and dark greys to almost solid black, could be reproduced only crudely on the coarse, absorbent surface of newsprint. With his understanding of photo-engraving processes, he could represent the greys by 'mechanical tints'. These were textures made up of fine lines or dots, the size and type specified by the artist from samples provided by the engraver. The Chrysler booklets give a straightforward idea of what the cars looked like, the quality of the printing and paper a reflection of their gleaming elegance. The graduated lines, still grey or black, are used as a decorative link to the advertising.

As a commercial artist, Ashley was original and successful. On the other hand, his efforts to commercialise art were less rewarding. The result was more often stylisation rather than style: modernity and modishness. This was no disadvantage in advertising. Rather than grasping the thoroughgoing Modernism as practised and promulgated by the émigré designers, or those such as Tschichold who wrote in the English trade journals, Ashley borrowed visual style from artists — even from his friend, Ben

40 *right* Ashley's 1938 'Beer is Best' poster is one of his most effective designs, and striking in its near-abstraction of form and colour. The tilt of the rectangles implies the drinkers' conviviality; the beer lettering, as labels, on white and white on red suggests the sharpness of light ale and the warm comfort of stout.

41 & 42 *opposite* Crawfords' beer campaign varied in its styles to match a wide audience. Darts-playing drinkers, their presence suggested in an artfully-lit photograph, are addressed with genteel graphic elegance and sublimely sentimental copy text. Ashley's more robust illustrations and calligraphy are judged more suitable for rugby players and golfers.

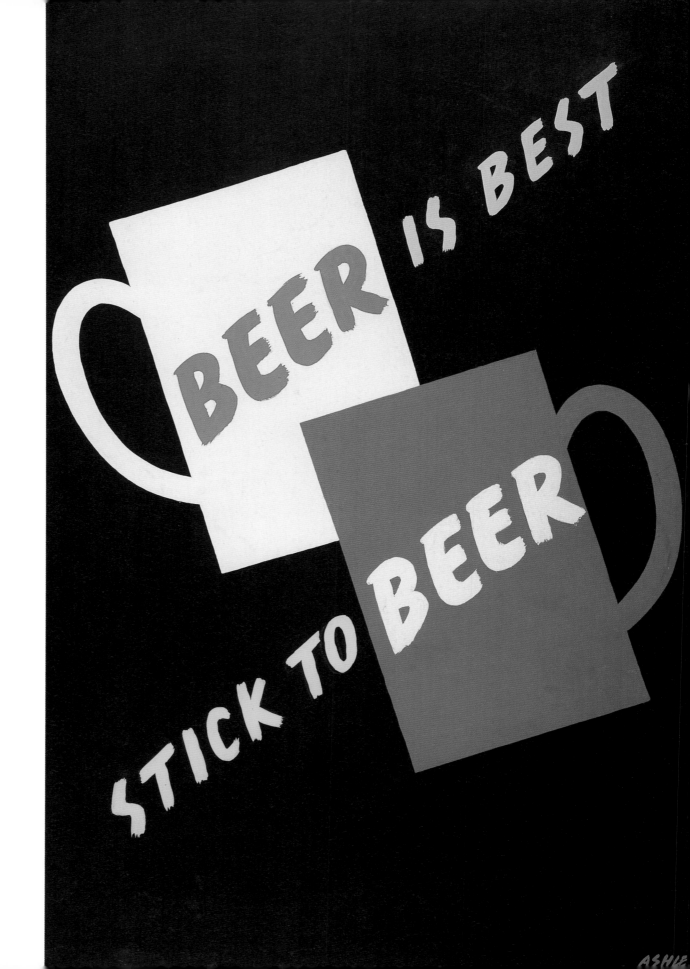

Beer is best...

Around these glasses all subjects are discussed but no angry fists are thumped. No foreign beards are wagged, or dangerous doctrines spread . . . No fiercer sound is heard than the click of a cricket bat on the green outside. No heads are cracked—but only jokes. For this is the drink of a free people—ale or stout, the drink of England and of sport and peaceful life.

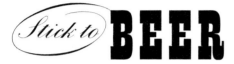

Stick to **BEER**

BEER IS BEST

The rugger man is not genteel
He tears around in mud
And seizing his opponent's heel
He floors him with a thud.

All this requires both heart and nerve
The strain is most severe
And *that's* why rugger men preserve
The rule of . . .

The goalie has no fun at all
With cap upon his head
He very rarely kicks the ball
His knees are cold and red.

But when a sudden rush comes on
His team mates have no fear
They know they can rely upon
Such men who . . .

STICK TO
BEER

Nicholson. This was a distraction from advertising as Read saw it: 'The element of wit or humour — the bright idea — is the occasion for a good poster or advertisement; even a purely typographical layout, if it is to be graphically effective, must have a bright idea behind it.'[14]

Imitating art was no substitute for a bright idea. In 1937 Ashley realised the problem, implicitly — and brilliantly — criticising himself and his colleagues:
The modern movement in the arts is obviously influencing commercial designing. Anxious to progress, [the designer] *embraces these tendencies with avidity. In his enthusiasm, however, he forgets that the medium of publicity in which he works is only a means to an end.*

Unconsciously it becomes for him an end in itself, a vehicle for modern forms. He now starts on a geometric pattern-making era — in which all the writer's headlines and text become inextricably woven together with cubist shapes and symbolic drawings, the whole becoming a complete mixture of forms and colours. Very dramatic, very modern — but far from clarifying the subject in which it is designed to interest the public.[15]
Ashley describes the value of studying works by abstract painters citing Mondrian, Ben Nicholson and Moholy-Nagy. He says that the work of the layout man and typographer *tends to be of necessity asymmetric in form because an advertisement or pamphlet cannot be a slow sequence of ideas like a book, but is five or six ideas all at once.*

The sorting and relating of these ideas, so that they lie down together without conflict becomes a problem of ingenious placing and arrangement if the result is to be a balanced whole.

The abstract shape formed by groups of words in headlines or text can only be seen to their best advantage when arranged by typographers sensitive to the subtlest asymmetric balance of forms in space.[16]
Speaking in these terms, Ashley contributed one of the few considered statements on the process of design for visual communication. In Moholy-Nagy, whom Ashley was responsible for employing as display manger at Simpson for its first year, Ashley had seen an artist whose designs did not imitate his own work as an artist, but were an extension of his creative activity in another medium.

Bent over the near-vertical drawing board, rather than an artist's easel, brush in hand, Ashley is the image of the commercial artist. It could hardly be more explicit. The raw material, word and image, are on the paper. A smart magazine asked, 'Have you seen the oval blob of light blue and dark blue with MILK smeared across it in cool white letters?'[17] Ashley's brush is the artist's archetypal tool. He never 'smeared' with it, but used it accurately, elegantly and intelligently. Intelligently, because for advertising it was efficient, not only in readability, but also in a technical sense. A headline in brush lettering was ready to be made into a block: there was no need for typesetting first. The 'milk' lettering could reappear with new copy lines. There was no objection to the same technique being applied to another drink. This time, there was no image just the bald slogan, 'Stick to Beer' or 'Beer is Best' [**42**].

43 Ashley described the house style that he designed for KLM in 1949 as 'the ball and stripe'. He said that it 'proved flexible enough to be used on posters, advertisements, timetables, cigarette boxes, book matches, etc, but became recognisable as the KLM pattern, or handwriting, in the thirty-four countries and sixteen languages in which it has been used.' Ashley could turn his hand to an appealing commercial style. He works the circular KLM badge into the centre of a flower whose petals radiate like the spring sun, the leaves repeating the shadow of the disc, giving it what Ashley described as 'an interesting stereoscopic effect'.

As social distinctions declined with the war so did the aspirations of advertising to link its graphic styles with fine art, or even with modern design.

44 The advertising idea for Christmas tree lights mimics the music-hall comedians' repartee. In this poster design of 1935, Ashley wittily adopts the restricted graphic possibilities of the illuminated signs made up of individual light bulbs, which were a new and popular advertising medium before the Second World War.

45 The basic elements of the KLM style: the disc enclosing the badge and lettering was intended to symbolise the airline's global activities.

46 This strong, recognisable trademark for Nestlé's permanent-waving system dates from the 1930s. Although there is no record of its use, it is nonetheless a vivid demonstration of Ashley's graphic skills: black line on white to suggest blonde and waved, white line reversed out of black for dark, straight hair.

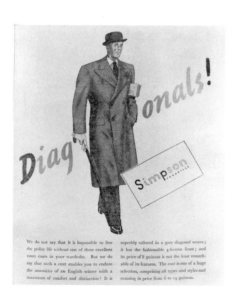

47 Since the time when he placed the Chrysler car running at a slope up the page, Ashley had used the 'set-it-crooked' trick only as a formal device. Now he was able to make a literal connection between the diagonal and the weave of the overcoat's cloth.

'Milk', as lettered by Ashley, was almost a logo. What are now generally known as logos were then described as 'name styles' – a consistent form of lettering used for the company name. The same type of letter might be part of a trademark. Not significant in Ashley's output, but one surviving example – evidently unused – was for Nestlé's permanent waving system [46]. More than trademarks, Ashley was interested in establishing what he called 'company handwriting' where everything 'that needs to be told can be said to both the trade and the public in a manner that will be not only immediately recognisable, but will also evoke pleasant associations, thus achieving an ever increasing cumulative effect'.[18] He was describing what came to be called 'corporate identity'. After the Second World War, Ashley provided a 'handwriting' for KLM (Koninklijke Luchtvaart Maatschappij), the Royal Dutch airlines. The company wanted to retain its badge – a monogram with a crown and wings – that was used on the aircraft and on staff uniforms. Ashley redesigned the logo, dropping the full stops after the letters and arranging the badge and the full name in a circle on a background of diagonal stripes.[19] The 'ball and stripe' appeared on all the airline's printed material, from posters to books of matches [45]. Advertisements included the stripes, which Ashley cheerfully said, 'evoked ideas of gay holidays under sunny awnings abroad'.

SIMPSON PICCADILLY

With his work for Simpson, Ashley enlarged the concept of 'company handwriting' in a way that had never been done before. As such, it is his most long-lasting contribution to the history of design in Britain. Ashley was perfectly fitted, in experience, talent and enthusiasm, to carry the project through successfully. If cars were a passion for Ashley so were clothes. S. Simpson Ltd was a firm making clothes under the name Simpson and, later, also as DAKS. They now planned the store known as Simpson Piccadilly and from the outset Ashley was concerned with a total design that gave a unifying coherence to the whole enterprise.

The logo was crucial. 'The name', Ashley said, *was not an unusual one, so it had to be given a unique visual form. This form had to be suitable for black and white reproduction in newspapers as well as being capable of being used in a variety of colour combinations in magazine advertisements and for showcards and displays in the shop. It had to be suitable for large-scale display in metal letters on the front of the building. The logo had to be capable of being stamped onto or into merchandise like cigar and cigarette boxes, shoes, hats, etc. or to be woven into labels for shirts, sweaters and similar garments. It had to appear on menus and invitation cards and on all the firm's stationery. The special package designs incorporating the name form had to link in and echo the interior decor of the store.*[20]

48 This is Ashley's most celebrated work as a modernist graphic designer. For the DAKS trade name – a convenient rhyme with 'slacks' – he drew the four bold letters widely spaced.

The figure is cut-out, the elbow resting on a single line, and the diagonal headlines, following the angle of the bent leg, fuse the photographic with the typographic. The low camera angle and lighting, suggesting sunlight and the outdoors, enhance the texture of the material and its seductive drape. The contrast of the flat coloured square with the three-dimensional depth of the photograph anchors the image in the space.

S. Simpson Ltd, 92/100 Stoke Newington Road, London, N.16

The success of the century

It's no exaggeration. At one time, really practical slacks for games just did not exist. Then along came Daks, with their comfort-in-action cut, superb hang and neat shirt control. And what happened? Crack sportsmen—not to mention some half-a-million other men, took to them with enthusiasm. Australian Test Teams have worn Daks since 1934 — and they're wearing them again this year. Have you ever tried on a pair of Daks? If not—go and do so. First you'll need some Daks greys. But ask to see the Daks chart, and have a look at the cool tropicals, crisp linens, the rough stuffs, corduroys, and all the forty-one colours and eight materials. 30/- a pair from all good men's shops, or write Simpson, 202 Piccadilly, W.1.

49 The punning headline is typical of a series of DAKS advertisements under Ashley's art direction, which combines copywriting wit with his elegant typography. The low-level photograph is less a picture than a diagram designed to reveal the trousers' 'comfort-in-action'. The careful, heavy cropping of the image reduces its pictorial perspective so that the surface plane of the paper is undisturbed, and the flatness heightened by both the even texture of the typeset copy and by the almost-square space where the DAKS logo is angled.

What Ashley devised took the form of a kind of visiting card which appeared, usually at an oblique angle, on every item that the public saw, including the advertisements. The letters of the name Simpson had the 'S' and the 'p' in different strengths of tone from the rest of the word [**51**]. For the store, the 'p' became the first letter of 'Piccadilly'. For DAKS, Ashley chose condensed capital letters, alternating in tone or colour. (The word 'DAKS' was an invention, said Ashley, replacing the first idea of abbreviating 'vacation' to 'Vacs'.) There was also a less successful monogram device — an 's' in the form of a needle and thread — designed for use on cutlery and plates, which appeared in advertising when Simpson introduced ladies clothes in 1937 (see p.68). The shape that advertising for Piccadilly took, said Ashley, 'was worked out in great detail, including prototype drawings for merchandise and the broad copy approach, before the store in Piccadilly was built in 1935. In this way the indefinable unique aura (for want of better words) envisaged to be the public's conception of the store was established.'[21]

Also, according to Ashley, the forward planning was remarkable:

The general form of the window displays and all the lettering throughout the store was arrived at to echo the style and typography of the advertising.

Even the artist to do the illustrations in the advertising was settled — since the visual atmosphere of a company's advertising is considerably affected by the consistent use of a given artist's style of work.[22]

One of the principal illustrators for Simpson was Max Hof, whose technique was brush drawing, which meshed well with Ashley's style of script lettering. Moholy-Nagy was brought in to help with display inside the shop and in the street windows. When the new building opened, Simpson advertising saturated the newspapers and magazines read by their target customers, and this included those produced for cruise ships. In the first year Crawfords produced more than 100 different press advertisements. Some had catchy headlines, 'Slacks and shorts for all the sports' was typical. Or they were punning. The choice between double-breasted or single-breasted suits, was

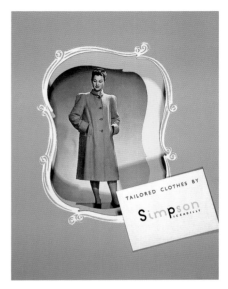

50 *left* Ashley showed his decorative skills in overprinting colour, a popular technique for graphic designers in the 1950s. It owed something to American Expressionism in its suggestion of atmospheric space. Designs were worked out with letters cut out of coloured paper, tissue paper or film.

51 *above* This three-dimensional showcard was conceived as a picture within a picture, typical of the influence of Surrealism in advertising photography. The model in her overcoat is pushed below and beyond the surface of the page, whereas the modernist aspiration was to emphasise the page's flatness by rectangular elements which echoed the geometry of the page itself.

52 *right* The popular cartoonist Frank Ford was commissioned for a series of advertisements with the same headline, taking advantage of the most unlikely items in Simpson's stock. By contrast, the comic idea draws attention to the store's more conventional goods and attractions listed below in a constellation around the 'visiting-card' logo which is superimposed on the kind of brushed cloud to be found in Ashley's paintings of the time. The cloudy airbrushed swirls in the background of Frank Ford's drawing have echoes of abstract art, so adding to its fashionably modern look.

The typesetting, as with most of Crawfords' work for Simpson, is in the Gill Light and Gill Bold typefaces. As the art historian Nikolaus Pevsner put it, Gill Sans was 'the favourite of all those who were or wanted to appear modern-minded'.

Sorry I'm late—but look what I got at Simpsons!

When a man tells you he's 'just popping into Simpsons for a stud' don't expect to see him come popping out again a minute later. For once a man is in Simpsons he's apt to lose all sense of time. Blame the wonderful barber's shop, if you like, for tempting him to a shave. Blame the snack bar for having half his friends in it. Blame the aviation exhibition on the fifth floor for showing him a flying flea. Blame our shirts, our ties, our shoes — for bewildering him with choice. But don't blame him. It's not fair! After all, what man *can* tear himself away from Simpsons?

OVERCOATS SHOES RIDING KIT
SUITS DRESS CLOTHES JEWELLERY
HATS THEATRE TICKETS FLOWERSHOP
CIGARS TROPICAL KIT
GIFTSHOPS FLYING KIT
BEACHWEAR BARBERSHOP
AEROPLANES ATHLETIC SHOP SHIRTS
FORMAL CLOTHES SNACKBAR GUNS AND RODS
TIES TRAVEL BUREAU BOATS

Simpson PICCADILLY

'D.B. or not D.B'. There were running campaigns, a series of three or four: drawings of different situations with the same caption, 'Sorry I'm late, but look what I got at Simpsons!' [52]. Snobbery was part of the appeal. The distinguished-looking customer asks the chauffeur, 'Now James, what have we forgotten?' and the message is, 'Buying your chauffeur's livery at Simpson has only one drawback. You nearly always want to buy a car to match its magnificence.' Social class was shamelessly exploited. An overcoat was advertised with the endorsement that, 'The Earl of Westmorland who is known as one of the best-dressed men of our time was so delighted with this coat that he allowed it to be called exclusively by his name.' And there is even a Westmorland logo.

Commercial artists no longer depended on art for a graphic style. DAKS advertising became properly modern. The type was the kind of 'grotesque' – nineteenth-century sans serif – used by the continental practitioners of the New Typography. Photography was used even on newsprint, photographs carefully cropped to focus on the item of clothing intended to tempt the reader.

ASHLEY AND TYPOGRAPHY

The modern style was suited to DAKS. Where Tschichold used the same aesthetic in a poster for a classical concert and in an advertisement for corsets, Ashley matched the style to the product. Larrañaga cigars and Wolsey socks [22] needed the comfort of tradition implied by the informal brushwork of his drawing and lettering. Ashley understood the needs of typography and how to make it readable. In the agency, he had professional typographers who could handle the complications of making text fit. He designed his own book, *Advertising and the Artist*, but he had no intensive practice or training in typography as a craft. In 1938, when the Modern Architectural Research Group held a didactic exhibition on housing and planning, Ashley designed the catalogue [56]. Members of MARS Group were Ashley's progressive friends, but their rigorous, logical Modernism, carefully reflected in the design of the exhibition, met no comparable response in Ashley. The design looked modern, spacious and asymmetrical, using Gill Sans, but the typography lacked the clear structure which Tschichold had demonstrated in *Circle*. Limited as a typographer, Ashley none the less had a true understanding of the shape of letters. The decorated 'w' in the near symmetrical Miss Worth logo made it easy to place in advertisements and was also practical for use in all types of labelling [55]. In 1930 Monotype produced two versions of the lettering which Ashley had drawn for Chrysler advertisements. The typefaces, in capitals only, were known as Ashley Crawford (with small, thin serifs) and Ashley Crawford Plain. Ashley Script, based on his brush lettering, with lower case and figures, had far more widespread use after its launch by

Ashley Script was issued by Monotype in 1955

53 *above* Ashley was away in the army during the war and, like many designers, engaged in camouflage. For Crawfords and Simpson it was business as usual, as in this poster for women's uniforms drawn by A. E. Barbosa. The 'visiting card' name style in the waved form was always intended to identify women's wear.

54 & 55 *below* Name styles for Larrañaga Cigars and a junior range by the long-established fashion house of Worth

56 *right* The Modern Architectural Research Group's 1938 exhibition was one of the landmarks of the Modern Movement in Britain. Ashley, friendly with several of the participants, designed the catalogue. He illustrated the architect's building materials in a hybrid style, part realistic illustration, part 'abstract-art' shapes, decorated in the naturalistic patterns of brickwork pointing and grained wood, with the addition of Ashley's favourite star embellishment and brushed-in 'cloud'.

57–60 *opposite* Between 1948 and 1951 Ashley gave Liberty, the London department store, a house style based on a slab-serif, so-called 'Egyptian' letter 'L'. The same form is used for the 'I' on the Intrigant perfume pack. Stars made up the large letters and were repeated on packaging as an overall patterned texture.

Monotype in 1955. In fact, by this time, the style of Ashley's script lettering was commonplace, and much imitated. Crawfords had its own specialist in the Ashley style.

With the outbreak of the Second World War in 1939, before Ashley volunteered for military service, Crawfords was commissioned to produce posters for the state-run General Post Office. Given only type to persuade the public to 'Help the Postman', or that 'Communications are Vital', Ashley's sober organisation of the message was at least as compelling as his consumer advertisements. And in 1940 he paid discreet homage to Ben Nicholson in the poster 'Save for Supremacy'. There was a perverse oddity that Ashley, after spending years making people notice things, spent the war as a camouflage officer whose business it was to make things invisible.

ASHLEY'S POSTWAR WORK

As one of the senior figures in advertising and commercial art, Ashley slowly became an institution. He took on awkward official work where the commissioning circumstances were often as confused as the resulting design. In 1946 he supplied a poster for the *Britain Can Make It* exhibition at the Victoria & Albert Museum, London, where he was also responsible for the display in the men's clothing section. ('Britain Can Make – What?' asked one newspaper headline.) In a road accident prevention campaign, Ashley could find no image to match the slogan, 'Keep Death Off the Roads'. The literal, clichéd images – flags and cogwheels – of his British Industries Fair posters and the coarsely doodled circles in the *For Bill and Betty* exhibition poster, show a less assured, less inventive Ashley at work [**61**]. And while he called on many of the

best poster designers to work for Crawfords – contemporaries such as Abram Games and Tom Eckersley – his younger colleagues were overtaking him with fresher ideas. Other designers took Ashley's informal style and gave it new life in consumer advertising. Arpad Elfer for the D.H. Evans store and Hans Schleger with MacFisheries used similar brush lettering and dynamic layouts.

Working for Liberty, Ashley demonstrated that he had kept his grasp of middle-class consumer retailing and his skill at 'company handwriting' [**57–60**]. An old, established family firm, unlike Simpson, Liberty carried reminders of its links with the Arts and Crafts movement in its partly mock-Tudor exterior. The company's textiles were famous for their pattern and quality. Again, Ashley devised a modernising plan of 'total design' – for everything from the advertising, packaging, labelling, stationery and catalogues to the painting of the delivery vans. There was no echo of Arts and Crafts in the logo, but a contemporary, refined style: a capital 'L' formed of stars or spots. The word Liberty was repeated in a bold serif type. The texture of the 'L' sometimes continued in a different tone or colour over the background.

Ashley had a favourite repertoire of decorative devices. The motif of discs and dots, used for Martini, was the unifying feature of the advertising and labels for Maconochie's soups. 'Bill and Betty', who could have been suitable customers for Richard Shops – less exclusive fashion stores than Simpson or Liberty – might have recognised the whorls in the background texture of the advertising.

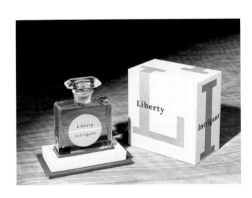

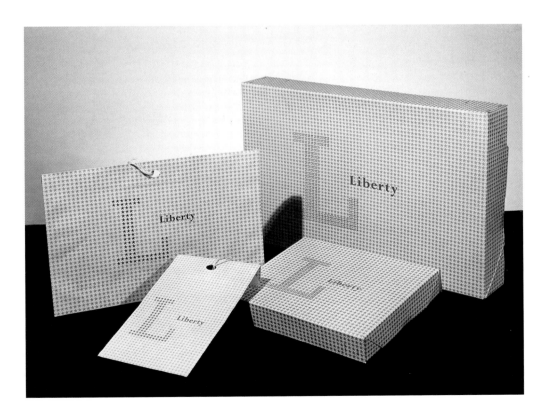

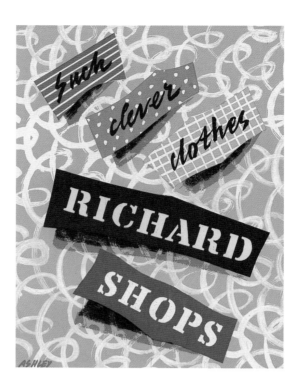

61, 62 & 63 Ashley had a favourite repertoire of decorative devices. Customers for Richard Shops – fashion stores, but less exclusive than Simpson or Liberty – might have recognised the whorls in the background texture of the advertising as belonging to the 'Bill and Betty' poster of 1952. This poster combines Ashley's brush calligraphy with the decorative loops that can be seen in his pre-war textile design.

The motif of discs and dots, used for Martini in 1955, was also the unifying feature of the advertising and labels for Maconochie's food products.

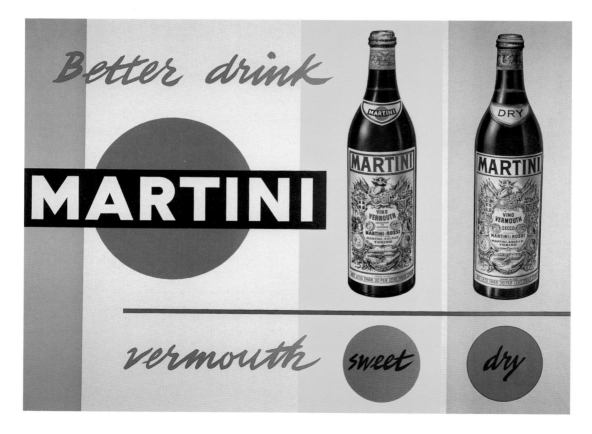

64 By the 1960s, while Ashley remained art director at Crawfords, only his DAKS logo had survived. The restrained wit and elegance of his early work was no match for the Italian-American aspirations of the 'new men'.

65 & 66 *right* Ashley's branding for Pretty Polly stockings has proved one of his most enduring designs. Horitcultural motifs were a favourite in his later work, even employed in advertising Enkalon, a new synthetic fibre, in 1962. The design on the right shows Ashley still absorbing new influences at the end of his career with an awareness of the new pop culture.

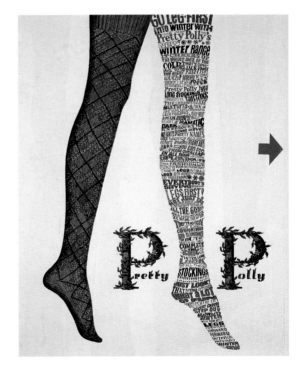

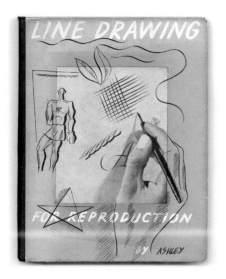

67 Reprinted and revised after the war, Ashley's how-to-do-it book first appeared in 1933. Most books of this type would show readers only the type of work they could imitate, whereas Ashley provided examples of draughtsmanship by the best contemporary, even avant-garde, artists.

It was also a guide to the technical processes, and Ashley generously explained the ways to achieve the graphic effects of which he was himself a master.

When Ashley was established in his career he wrote the popular guide to *Line Drawing for Reproduction*; so popular that it was revised and reprinted during the war, at the time of severe printing restrictions. There were two subsequent editions in the postwar years. The book is practical, in a 'do-it-yourself' way, explaining the tools and equipment and the technical aspects of reproducing drawings to produce special graphic effects. By including examples of artists' draughtsmanship, Ashley set standards beyond the mundane aspirations of the commercial art studio. Here were drawings by modern artists – Jean Cocteau, André Masson, Henry Moore, Picasso – even a montage, an iconic image of the 1920s, by Willi Baumeister. Addressing readers as professional colleagues, Ashley was not patronising, but sharing his enthusiasms.

Ashley suited his message to his audience. When he talked to the Double Crown Club in 1937 his paper titled 'Visual Expression' was printed in the magazine *Typography* the following year. Members of the club were in general diehard traditionalists, but Ashley was a brave spokesman for Modernism. His audience would have expected him to refer to the famous French poster designers, but he includes Tschichold and Moholy-Nagy (names familiar to advertising studios from articles in the commercial art journals) as well as his Hampstead friends, 'abstract painters like Mondrian, Ben Nicholson and Moholy-Nagy [who] have opened up new possibilities in spatial expression, the study of which should be of inestimable value, particularly to the layout-man and typographer.'

Despite his avant-garde references, Ashley keeps his feet on the ground. He points out that words and image are interdependent: the image is not merely an illustration of the words, but together they convey an idea. According to Ashley, 'The contemporary designer stands or falls according to the degree to which his use of form and colour contributes to the rapid comprehension of the ideas which the advertiser wishes to convey.' And he ends this part of his address saying, 'In other words, I believe the only ideal a designer should work to is complete clarity of expression. Not only clarity of words, of picture, but "idea" clarity.' Ashley, in recognising that graphics are a matter of communication rather than aesthetic style, is truly modern.

Almost twenty years after his 'Visual Expression' talk came Ashley's *Advertising and the Artist*. Into this slim volume – only forty-eight pages with nearly 130 illustrations – he packs a history of modern art, its effect on advertising, an account of the development of commercial art, modern typography, and the social role of advertising. And he introduces the idea of 'designing inside out'. That is to say,

simple direct statements in pictures and type – their outward form arising out of the inner requirements of their parts, as in modern architecture, where the external asymmetric appearance is the result of the interior planning, in contradistinction to the symmetry of traditional architecture, with its emphasis on the façade, which is often at the expense of the comfort and convenience of the rooms inside. The modern point of view, therefore, is to design from inside out, as opposed to the traditional, which is a tendency to impose a preconceived solution to a problem by designing from outside in.[23]

Ashley's appearance and gentlemanly manner, accompanied by the same enthusiastic optimism as when he joined Crawfords, suited him for the role of the elder statesman of advertising. As a chairman of committees and member of boards of governors, he helped the Society of Industrial Artists to 'raise the status of artists working in commerce'. In a letter to *Advertisers Weekly*, in November 1964, Margaret Havinden complained: 'for too long advertising artists have been under-appreciated in this country, just asked to do finished artworks for preconceived ideas of copywriters, account executives or advertising managers.'[24] But Ashley had long ago transcended this position: one of the first to be an 'art director', part of a team where he became first among equals.

While the aims of art and advertising have remained distinct, the processes have converged. Artists – conceptual artists, at least – now share with advertising designers their concern with ideas and meaning. Since Ashley's day, advertising has become a conceptual art.

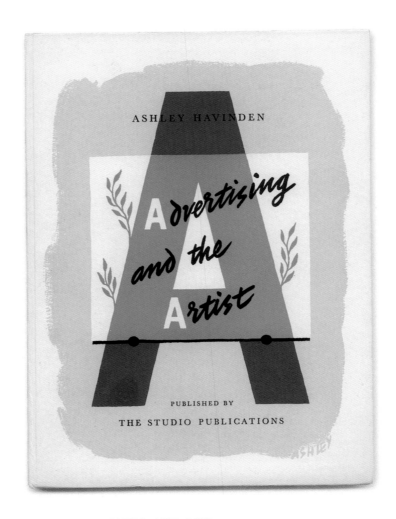

68 *Advertising and the Artist* was a book in two parts: an essay, followed by an historical anthology of graphic design, reproducing work by Ashley's predecessors, heroes and colleagues and a few designs of his own. In little more than a dozen pages of dense text he describes the changes in advertising layout and typography through the influence of modern artists. He pays tribute to all the design endeavours in the first half of the twentieth century and Ashley finally looks forward to 'a society healed of one of its most damaging fissions, the cleavage between the artist and the ordinary man'.

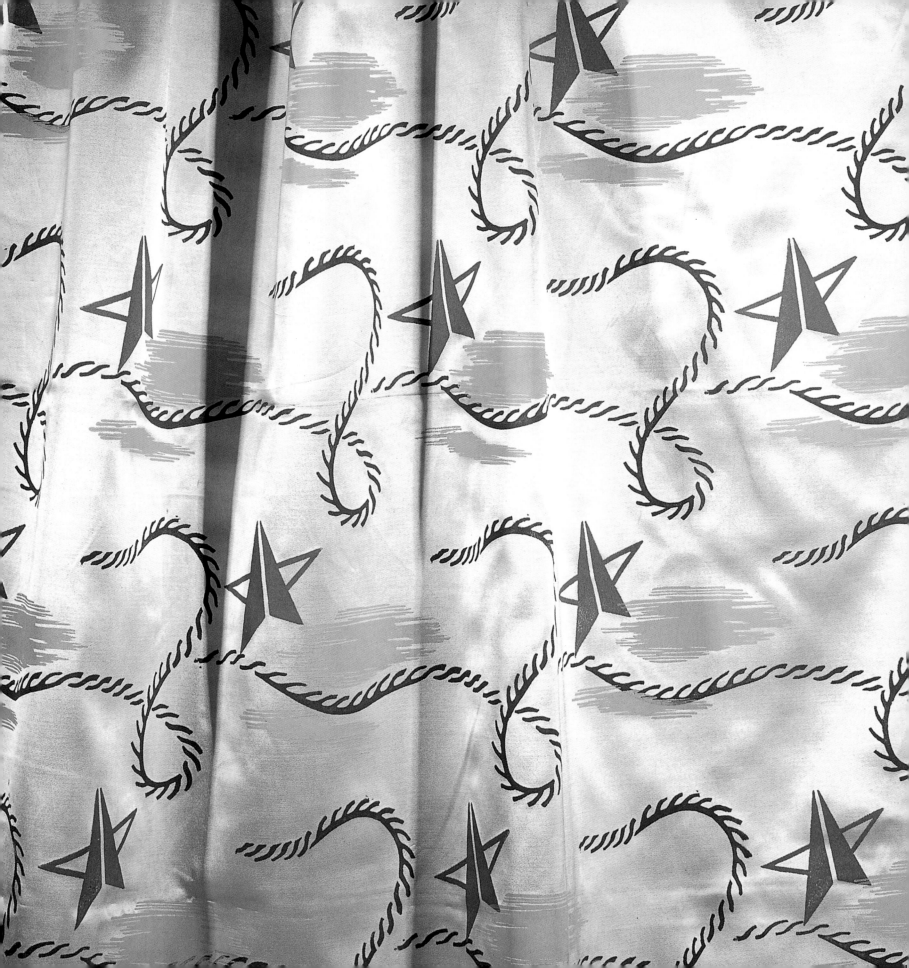

ASHLEY HAVINDEN
ARCHITECTURE AND INTERIORS

Ann Simpson

In a posthumous tribute to Ashley Havinden, the graphic artist and designer F.H.K. Henrion recalled that Ashley's 'most moving and endearing quality ... was his absolute dedication to design and to the wish that design should improve every aspect of life and environment'. According to Henrion, 'His involvement in design and art was total, and he would go to any length to learn what other artists and designers had done, to improve his mind and performance, as he had an almost childlike belief in the ultimate salvation of the world through design.'[1]

Ashley's belief in the redemptive power of design was not unusual for someone involved in the advertising world during the 1920s and 1930s. But they were ideals first formed in childhood. Ashley's father, Gustavus Havinden, following the welfare ideology of his friend Lord Leverhulme, had established an 'ideal garden factory' in Watford before the First World War, called Delectaland. The business was to embody the welfare ideals of a well-designed, modern, humanised industry.

At the beginning of his own career in advertising, Ashley found two mentors who helped to develop his thinking: William Crawford and Stanley Morison. On joining W.S. Crawford Ltd in 1922, Ashley found himself in a company whose founder actively promoted the idea of design as a socially redemptive strategy. Crawford believed that a new 'twentieth-century renaissance' would arise from the pursuit of design, enlivened by the new international style of architecture and the new media of film and photography.

The near future is great with possibilities, Art, Industry and Advertising are being welded together to produce something that goes further than the development of commercial interests and making money. This 'something' ... is already penetrating more and more into the national life, educating the social unit to better standards of taste and thought, thus opening the way to reforms throughout the social fabric.[2]

Both Crawford and Morison were active during the 1920s and 1930s in the cam-

69 Textile: *Majorca* 1938, screen-print on satin by Campbell Fabrics Ltd for Duncan Miller Ltd

paign to improve the standard of art and design in British industry, which prompted a series of initiatives and inquiries. A new international image was sought for Britain through a reinvigoration of commercial design. This was to be brought about by bringing artists into the design process.[3] Ideas from continental Europe, emanating, in particular, from the work of Walter Gropius's Bauhaus and to be found in Le Corbusier's books on architecture and urbanism, were obvious sources of inspiration, which led inexorably in the direction of international Modernism. This prompted Ashley to investigate the new ideas on design emerging from Germany through current Bauhaus publications, which he bought from Zwemmer's bookshop near Crawfords' office in Charing Cross Road.[4]

Manufacturing was ready for change. The 1929 Wall Street crash and the depression that followed drove industry to greater efficiency, simply to survive. The protectionist legislation of the early 1930s shifted consumer focus from imports to home produced goods and this opened the way to new design ideas.[5] Artists like Paul Nash were closely involved in the debate and, through his writing, Nash became a champion of radical design. At a time of bleak financial outlook and general lack of patronage, artists found commercial commissions only too welcome. Frank Pick, publicity manager for the London Passenger Transport Board and first chairman of the Council for Art & Industry, commissioned poster designs from Nash, E. McKnight Kauffer and others. Shell Petroleum employed artists for their *Shell Guides*.

This new-found union between art and design remained an uneasy one, however, for some artists found it hard to accept the compromises which the production process and the market demanded, while other more established 'industrial artists' felt threatened by what they saw as an invasion of their territory. In 1930 a new representative body, the Society of Industrial Artists, was formed to give the artist in industry professional standing. Among its early members were Paul Nash, Serge Chermayeff, and Ashley Havinden.[6] The gulf between the 'fine artist' and the 'commercial artist' was keenly felt and it was a gap that was infrequently bridged; Ashley was a rare example of a designer who managed to achieve recognition in both worlds.

He embraced professional ideals and regarded it as the designer's responsibility to have an acute awareness of current trends. According to Ashley

the type of thinking which produces a constructive result is most likely to emerge when the designer is himself in sympathy with all the manifestations of contemporary life. He should be familiar with all forms of modern expression in fields other than his own, because it is through the influence of modern architecture and the experiments of the purer arts of painting and sculpture that the new visual forms will be found … Abstract painters like Mondrian, Ben Nicholson and Moholy-Nagy have opened up new possibilities in spatial expression, the study of which should be of inestimable value, particularly to the lay-out man and typographer.[7]

In this he appears to have been influenced by Herbert Read's book, *Art and Industry*, 1934. Read had examined the role of the abstract artist who, through his research into

pure form, could be seen as crucial to the aesthetic and commercial well-being of the country. He put forward Ben Nicholson, Piet Mondrian and Jean Hélion as exemplars. Ashley followed his own advice and developed a keen interest in art, architecture and interior design, both as patron and as practitioner.[8]

ASHLEY AND ARCHITECTURE

During the 1930s Ashley found himself part of a group of architects and designers who were key figures in the promotion of Modernism. Serge Chermayeff, Wells Coates, Maxwell Fry, Walter Gropius and Rodney Thomas were all friends of his and he had professional contacts with Frederick Etchells, Joseph Emberton and Oliver Hill. Wells Coates, Chermayeff and others formed the Twentieth Century Group in 1930, to 'sell' the idea of Modernism to a conservative public, and in 1933 the torch was passed to the MARS Group founded by Wells Coates with Maxwell Fry. Ashley designed a brochure for Hill's Frinton Park development in 1934 and an exhibition catalogue for the MARS Group in 1938.[9]

Ashley's first contact with the new architecture came in 1929, when Crawford was expanding the firm by taking on several new directors, Ashley among them. Edward McKnight Kauffer introduced Frederick Etchells to Crawford, who invited Etchells to redesign the firm's offices in High Holborn. He and his partner, Herbert Welch, re-cased the existing structure in steel, black marble and glass to produce what is acknowledged to be the first recognisably modern movement building in London [**70**].

As a painter, before the First World War, Etchells had been involved with the Omega Workshop and British Vorticism. Turning to architecture in the late 1920s, he brought the ideas of Le Corbusier to Britain with his English translations of *Vers une architecture* (Towards a New Architecture), 1927, and *Urbanisme*, 1929. Ashley owned first editions of these and always acknowledged the influence that Corbusier's pragmatic rationalism had on him.[10] Etchells's building for W.S. Crawford Ltd was completed in 1930 and in Ashley's new capacity as a director of the firm he commissioned Rodney Thomas to design the furniture and fittings of his studio at Crawfords. Thomas was also an enthusiastic exponent of Corbusier's ideas. He had recently designed a studio for the artist Eileen Agar[11] and went on to design a two-storey wing for the Havindens' house at 20 Alvanley Gardens in West Hampstead.

The Havindens' house was neo-Georgian, with large rooms and good proportions, inside and out. Thomas's wing, built to house a studio as well as a nursery for Ashley's young family, was modernist; it was completed in mid-1932 when it was reviewed by Derek Patmore for *The Studio* magazine.[12] True to Corbusier's dictum that the house is 'a machine for living', Thomas created a studio which was both harmonious, responsive to the moods of the artist, and yet fundamentally practical [**71**]. Given the confined nature of the site, the design had all the economy of space and tight planning of a ship's cabin. The corners were curved, to prevent dust collecting, and the windows over the work desk projected outwards like a ship's prow, to catch the morn-

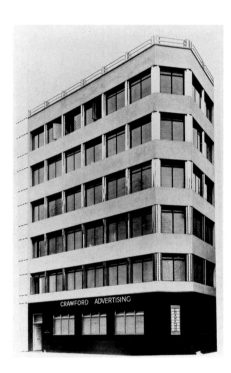

70 W.S. Crawford Ltd, offices at 233 High Holborn, London, designed by Frederick Etchells, 1929.

71 *left* Ashley's studio at 20 Alvanley Gardens, West Hampstead, designed by Rodney Thomas, 1932.

72 *right* Exhibition of rugs and textiles by Ashley at Duncan Miller Ltd, London, 1937. Rugs: on the wall *left Gnocchi, right Fontainbleu*; on the floor *Untitled*. Textiles: *back* Campbell Fabrics *Tufton* 1937, *front* Edinburgh Weavers, *Ashley's Abstract* 1937.

ing and evening light. The built-in furniture was curved to the contours of the room and made maximum use of the space available. The furniture was made of light-coloured wood, while the desk top was ebonised black, to disguise stains and pin marks. The walls and the ceiling were both painted a fashionable light cream, the only strong colour being that of a scarlet silk cord, which marked the junction between them. The curtains were made of natural oiled silk to minimise light absorption. For the photograph published in *The Studio* article, Ashley laid out his copy of the *Staatliches Bauhaus in Weimar 1919–1923*, and, propped up by the Rodney Thomas wall clock, the gouache drawing he made for the BP campaign of 1930–1. A few years later, the room was filled with his rugs and textile designs.

Ashley's younger brother, John Havinden, an innovative professional photographer, took the formal pictures of Thomas's work both at Hampstead and at the Holborn office. The brothers shared an interest in Modernism. In the late 1920s William Crawford became interested in photographic advertising and often used John's work, in campaigns for Eno's and Osram, for example, for which Ashley was art director. The photographs of the Rodney Thomas commissions were John's first venture into architectural photography. He was to become the best-known photographer of British modernist architecture.[13]

In 1933 Ashley and his wife Margaret visited the Fitzroy Square showrooms that Etchells had made for the American photographer and interior designer Curtis Moffat. Here they found a mixture of rare antique pieces set beside 'cutting edge' modern designs. The latter were mostly by John and Madeline Duncan Miller, who were in charge of Moffat's 'modern department'. John Duncan Miller was a furniture

designer. Shortly after meeting the Havindens, the Duncan Millers set up a show-room and gallery of their own, Duncan Miller Ltd in Lower Grosvenor Place, London. As advocates of Modernism, they promoted the cause of abstract art and, like the London Gallery (founded 1936) with which Ashley was closely associated, promoted the integration of abstract painting and sculpture with interior design. In April 1936 they arranged a show called *Modern Pictures for Modern Rooms*. Billed as an exhibition of abstract art in contemporary settings, it included works by Brancusi, Gabo, Giacometti, Hélion, Hepworth, Miró, Moholy-Nagy, Mondrian, Moore and Nicholson, all in the context of modern interiors. In his introduction to the catalogue, S. John Woods wrote: 'Abstract artists make statements sympathetic with today ... Abstract art builds the highest visual potential of our environments and enriches our lives by doing it.'

The Duncan Millers' flat in Fitzroy Square was furnished with abstract paintings and with furniture of their own design. On his first visit there, Ashley noted an abstract painting by John Piper and a stylised landscape by Jean Lurçat. During 1933 and 1934 the Millers and the Havindens dined together once a week, either in West Hampstead or in Fitzroy Square, and it was there that Ashley met Wells Coates, who subsequently introduced him to Chermayeff, Fry, Gropius (Fry's partner 1934–7) and Marcel Breuer. Duncan Miller was also responsible for Ashley's first meeting with Herbert Bayer and László Moholy-Nagy. In Moholy's London flat, Ashley also found a blend of abstract paintings and modernist furniture; he noted how Moholy transformed his ordinary rooms into austere white cells, with Alvar Aalto bent plywood tables, Breuer chairs and his own abstract works on the walls.

To escape from the city at weekends, the Havindens joined the Duncan Millers, Wells Coates and the cartoonist and illustrator Walter Goetz and his wife in taking a lease on Tufton Manor in Hampshire as a country retreat. They intended to entertain weekend guests and Ashley also hoped to pursue his painting. After two years, Ashley and Margaret decided to move permanently to the country. In 1938, they found a buyer for Alvanley Gardens, who took the house complete with its rugs and curtains, all of which had been designed by Ashley. An early entry date was a condition of the sale and, as a temporary measure, the Havindens took an empty duplex flat in Berthold Lubetkin's newly completed modernist Highpoint II in Highgate. It had been a show flat, decorated by the architect, and it was light and sunny. With its clean, warm-air central heating, it was a welcome change from the chilly Alvanley Gardens. The Havindens settled happily into Highpoint and stayed there for eleven years, only moving to the country in 1949.

The main feature of the Highpoint flat was its long main room, with floor to ceiling windows. The room had a double-height central space flanked by lower ends. This double height central space was hung with the Havindens' growing art collection. One end accommodated a comfortable living space, the other Ashley's studio cum-library [**73**]. According to the author of an illustrated article published in *House*

73 Ashley's studio at Highpoint, 1938

74 The studio wing at Roxford, designed for Ashley by Maxwell Fry, 1961

and Garden in 1947, all was calm, colourful, ordered, free from clutter and fussiness, giving restfulness for leisure and offering concentration for study. Another *House and Garden* article two years later records the Havindens' eventual move to the country.[14]

In 1949 they moved to Roxford, a Queen Anne house with Victorian additions at Hertingfordbury, in Hertfordshire. This was to be their home for the rest of their lives. The house happily accommodated Ashley's modern furniture, art collection and his own paintings. The rugs and curtains were also of Ashley's design, brought from Highgate, but the colours chosen for the walls — petrol blue, rust red, yellow — were brighter and bolder than in any of their previous houses.

In the 1940s and 1950s, Ashley and Margaret were preoccupied with running Crawfords. Ashley was also on several committees and travelled extensively. He had little time for painting, but as the 1960s approached, he commissioned his third studio, this time from Maxwell Fry [**74**]. This was an extension to the back of Roxford, which also included a new bathroom and dressing room and was completed in 1961. It was not Fry's style to make a toning pastiche; instead, he designed a structure based on a single steel column which carried an open gallery and an enclosed suite on the first floor. The remaining structure was timber-framed and weather-boarded. The principal feature of the studio was the enormous plate glass window which framed the view of the garden.

ASHLEY'S RUG DESIGNS

Although Ashley was best known in the 1930s for his bold posters and advertisements for Crawfords, he also developed a reputation as a designer of rugs and fabrics. He did not, however, regard this as a commercial activity. In the late 1930s, Antony Hunt noted: 'As with the case of his painting Ashley does not regard his fabric and rug designing as work. They are the result of play rather than of work, in the sense that he is independent of their earning capacity. What he designs in this way, therefore, is the spontaneous expression of his fancy, unprompted by other considerations.'[15] It is clear from an article that Ashley wrote in 1938 that he saw textile design as 'a visual equivalent in terms of draped materials of the modern painting and architecture of today'.[16]

It was in 1934 that the Duncan Millers first encouraged Ashley to try rug design. He described how, as a result of his experiments in the field of abstract painting, he 'jumped at the idea of the application of bold brush forms and vivid colours to produce "swooping" designs for modern rugs'. His gouache designs for these rugs are almost indistinguishable from his finished paintings, titled and signed with his distinctive signature: ASHLEY. The airbrush technique, derived from his commercial work and used in his paintings, is transposed in his rug designs into subtly mottled background colour. The strange abstract shapes explored in his paintings are also repeated, though other designs feature a lyrical, flowing, calligraphic line, using

75 *above* Rug: *Orpheus* c.1936, tufted wool, pink colourway, 260 × 153cm. Originally designed for Duncan Miller Ltd and hand-tufted by the Royal Wilton Carpet Company; this version was made for Liberty & Co, 1948 by Royal Wilton in blue and pink.
Private collection

76 *right* Bedroom designed by Duncan Miller, with Ashley's rug *Orpheus* on the floor, 1937

77 *above* Rug design: *Gnocchi* 1937, gouache on paper

78 *opposite* Wallpaper design: *Objects c.*1937, gouache and pencil on board

motifs drawn from nature. Although few of Ashley's rugs have survived, they can be appreciated in the sketches, finished drawings, photographs and twenty textile samples, which are held in the Ashley Havinden Archive.

Seven designs for wallpapers have survived, though there is no evidence that any of these were printed. From the many sketchbooks, sheets of pen and ink notes and tiny gouache cut-outs, it is clear that Ashley repeatedly reworked his ideas, repositioning the motifs, altering the colours and using squared paper to scale up the designs. Some sheets contain several ideas while others are more finished gouache designs. He used cheerful motifs including abstract forms, shells, birds and leaves, twisted ribbons and jaunty spirals.

79 Rug design: *Fontainebleu* 1936,
gouache on paper

Among Ashley's own news cuttings are two torn from the editions of *Vogue* from the 1930s. The first illustrates rugs with all-over patterns, designed by Duncan Grant and Vanessa Bell for the Omega Workshop. The second, 'Carpets for the New Flat', shows rugs by Jean Lurçat, with a twisted rope motif which features in some of Ashley's later designs, as well as two drawings of geometric patterns by the British carpet designer, Evelyn Wyld, whose flowing linear style was also an influence. The accompanying text referred to current simpler, more free-form designs, noting that few designers were now using all-over designs or borders.[17] Other British artists were producing rug designs at this time. Francis Bacon exhibited his own rugs and furniture at his London studio in 1930, Curtis Moffat showed work by McKnight Kauffer and Marion Dorn, while Paul Nash was designing rugs for the architect, Robert Symonds.

Some of the first rug designs by Ashley were commissioned by the Duncan Millers for hire to film and theatre companies as furnishings for sets in the new modern style. A constant supply of rugs and Duncan Miller furniture was needed to create a new effect for each set. These rugs were large and expensive to produce; Ashley's fee was 1s. per square foot, with the option that each rug could be bought back for £5. Gradually the polished wooden floors of Ashley's house in West Hampstead became covered with these rugs. They were hand-woven by the Royal Wilton carpet factory, which, with Edinburgh Weavers, was the main producer of these avant-garde designs at the time. Ashley's signed gouache designs for the rugs were mounted on buff coloured card, with the company's weaving stock number inscribed in ink at the top left hand corner, together with a title — Ashley always named his designs — and the date.

In 1936, the Dutch magazine *International Textiles* ran an article headed 'Ashley creates a new style for English Carpets'. His distinctive manner was characterised by sweeping black lines drawn in thick brushstrokes onto a pale ground, 'more background than pattern' as one reviewer remarked.[18] *Orpheus*, woven in 1936, is one of the few rugs to have survived. Measuring 3.2m × 2.3m (10ft 5in × 7ft 7in), it was made for a bedroom designed by the Duncan Millers [**76**]. The design shows a stringed instrument drawn out in arching black lines on a cream ground, spattered with a pale blue haze. It was used again in a smaller two-colour format by Liberty & Co in the late 1940s [**75**]. Another rug, *Gnocchi*, features prominently in a contemporary photograph of the 1937 Duncan Miller Ltd exhibition of Ashley's rugs and textiles [**72**]. In the gouache design for this rug, Ashley used his airbrush technique, which was transposed into wool as a single colour mottling [**77**]. Its bone-like motif bears a strong resemblance to the textile design called *Ashley's Abstract*, also of 1937, which featured in the same exhibition [**90**]. *Gnocchi* was bought by Mr Whitney and Lady Daphne Straight for the study of their London flat.[19]

Ashley worked for the Duncan Millers until the war: they selected one of his rugs for the 1939 San Francisco Golden Gate exhibition, which was displayed with a sculpture by Henry Moore and an abstract painting by John Piper. After 1939 there

was only one more design, for an Axminster fitted carpet for Richard Shops, which was based on the scrolling background of a poster Ashley designed for the company in 1949.

SIMPSON PICCADILLY

In 1935 Ashley was asked by Alec Simpson to produce twenty designs for rugs for his new store in Piccadilly. Simpson was renowned as the maker of men's self-supporting trousers produced under the name DAKS. Ashley had been responsible for their advertising since the launch of DAKS in 1934 and was already handling the design of the nameplate for the store and the needle and thread trademark based on the initial 'S' [**82**]. This device was praised by Herbert Read for being both 'human' and 'abstract' – a description which could equally have been applied to Ashley's rug designs.

The new store was built on a narrow site running between Piccadilly and Jermyn Street [**80**]. Simpson wanted it to be modern and so his architect, Joseph Emberton, produced one of the first steel-framed buildings in the country. The structure allowed virtually uninterrupted views from the front to the back of the shop, with a staircase set to one side against a wall of ribbed opaque glass. Particular features of the exterior were the concealed lighting, which brought the façade to life at night, and the special concave non-reflecting shop windows. These, which were the longest in London at the time, required considerable skill in lighting and display, which Simpson found in Ashley's friend, Moholy-Nagy. As part-time design consultant Moholy produced a series of novel window and interior displays, using screens pierced with square or circular openings. For the opening of the new store, he devised a spectacular top-floor

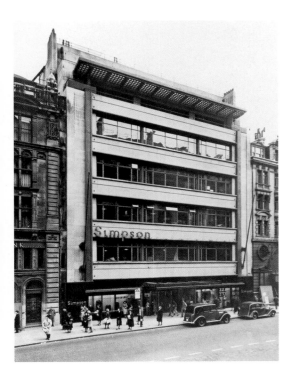

80 *above* Simpson Piccadilly designed by Joseph Emberton, 1936; frontage to Piccadilly showing Ashley's nameplate

81 *right* Sports' floor layout at Simpson Piccadilly with Ashley rug, 1939

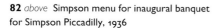

display on flying which featured a complete aeroplane. Moholy also suggested that the lift shafts should be cased in glass, so that customers could survey the different displays as they travelled up and down, but it was too late in the building process to incorporate this idea. When it opened on 29 April 1936, the store stood out as a beacon of Modernism, an exemplar of sleek new store design.

The very idea of a store devoted exclusively to men's clothing was a revolutionary concept in 1936. To attract the male customer, who was likely to feel ill at ease in such an establishment, Simpson installed a club room – complete with tape machine giving the latest stock-market prices – a barber's shop, a department selling dogs, a tobacconist and a theatre agent. The aeroplane on the top floor was an added attraction.

Ashley's rug designs were perfectly suited to this masculine modern building. From photographs and the gouache drawings of his designs, we can see he chose strong geometric shapes, incorporating his twisted rope design with the occasional star or leaf motif. They were mostly executed in colours such as snuff, tobacco, and black and white on a sand background. The rugs were either round or rectangular in shape and they varied in size from 11.7m to 3.9m (30ft to 10ft) in diameter and from 7.2m × 3.12m (18ft × 8ft) to 3.9m × 1.4m (10ft × 3ft). They became an integral part of the Simpson identity and were rewoven as they wore out. Ashley was paid a fee of 350 guineas, which was set up as an account for anything he wanted to buy from the store.

Ashley's rugs were not, however, exclusive to Duncan Miller Ltd. The design for *Starfish*, with its all-over pattern, was made by Edinburgh Weavers, who also printed many of his fabrics [84]. Detailed sketches and squared-up scale designs, together with a finished gouache, exist for this rug, which was executed in black and blue on

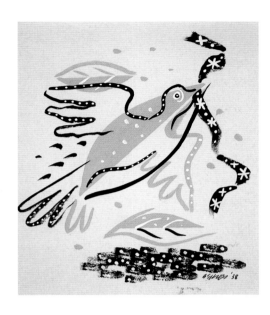

85 Textile and card design: *Bird with Ribbon* 1938, gouache on paper

cream and is now in the Victoria & Albert Museum, London. As Ashley explained, 'I approached the fabric field through rug designing and so the designs tend to be suitable for rugs as well as fabrics.'[20]

ASHLEY'S TEXTILE DESIGNS

Ashley's fabric designs were a natural extension of his rug designs. Sketches show how he took his ideas and worked them up into pattern repeats, experimenting with size, rhythm and scale against outline drawings of furniture. Antony Hunt described his first textile designs as being 'remarkable for the effective manner in which they showed a lyrical and gracious form of textile decoration at a time when geometric patterns were in the throes of staleness and anaemia. Whilst still preserving almost abstract forms, Ashley brought a little poetry and colour back into design.'[21]

From 1936 Ashley worked on furnishing fabrics for Duncan Miller Ltd and Edinburgh Weavers simultaneously. Both companies were concerned with the production of modern textiles for the modern interior. Ashley used the same motifs for both firms: shells, birds, leaves, stars and wavy lines or chains. However, the designs for the Duncan Millers, which were screen-printed, were different in character from those for Edinburgh Weavers, which were largely made for the subtle textures of woven fabrics.

The Duncan Miller textiles were printed by Campbell Fabrics Ltd onto a variety of materials: linen, satin, chintz and muslin, and in several colourways. The backgrounds were usually light and the designs were characterised by free-flowing curvilinear tracery. Three designs printed by Campbells, dated 1937, are all three-colour screen-prints onto light grounds in Ashley's characteristically lyrical, linear manner. *Arrarat* features a dove in black outline, drawn in a single flourish, wings spread and superimposed over a pale green leaf-covered twig [**87**]. Ashley had gleaned this idea from Picasso's line drawings of 1918–20 and had illustrated one such drawing, *Horse and its Trainer*, 1920, in his book *Line Drawing for Reproduction*, 1933. He recommended this exercise of continuous line drawing to the student of commercial art as invaluable training for the mind's eye. The same stylised bird motif was used by Marion Dorn in a fabric called *Aircraft*, produced for the Old Bleach Linen Company, Randalstown, Northern Ireland. *Tufton*, named after the weekend retreat, also featured a bird with spread wings and stars, set in a sinuous linear framework. It was printed in three versions: cream, red and blue on yellow linen; gold, brown and green on pearl sateen; and gold, blue and grey on natural muslin. The sateen version retailed at 11s a yard. A third fabric, *Majorca*, used Ashley's favourite twisted rope motif, combined with stars and pools of water over a light ground. This was again printed in three different versions: blue, brown and gold on cream linen; green, brown and black on cream sateen; and blue, rust and black on white muslin [**69**].

In 1935 and 1936 Ashley was also running an advertising campaign for the Carlisle-based textile firm, Morton Sundour Fabrics Ltd. The yellow sunflower

86 *above* Advertisement for Morton Sundour Fabrics Ltd, Carlisle, 1935

87 *opposite* Textile: *Ararat* 1937, screen-print on linen by Campbell Fabrics Ltd for Duncan Miller Ltd

against a green background, which he devised for them, reflected the two features for which the company was famed: its fabric which was guaranteed not to fade – the name Sundour was patented in 1906 – and its Caledon Jade green dye, said to be uniquely colourfast, which had been invented by the company's chemists in 1922. This device was used in all their press advertising, on brochures and on the cover of the firm's house magazine, the *Sundour Shuttle*.

James Morton established a new branch of Morton Sundour called Edinburgh Weavers in 1928 specifically to extend the firm's reputation for experimental design. In the 1930s it was run by his son Alastair. Ashley described how he

was approached by Alastair Morton to do fabric designs for his new firm Edinburgh Weavers – an off shoot of the well-established Sundour Fabrics Ltd. The purpose of the new firm was to produce the highest quality of furnishing fabrics with the intention of raising the standard of design ultimately of the more mass-produced products of the parent firm of Sundour. Alastair Morton had already commissioned designs from Marion Dorn, the best-known fabric designer at that time.

From correspondence it is clear that Alastair Morton first wanted Ashley's designs for the popular end of the trade. He asked for a range of small, four-colour designs to retail at 1s. 11d. per yard. A further more exclusive hand-printed range, with seven or eight colours would retail at 4s. 6d. per yard. According to Morton, 'We really would like you to do some for us, not for Edinburgh Weavers, but for the more general trade. This does not mean that they should not be really good designs, but only that they should not be sophisticated or exclusive.' By 1936 progress had been made and Morton advised him that he was sending 'a sketch showing how we intend to work it out, and I would like your comments on this. It has not been too easy, and some of the shapes I do not like too well. I think the brown colouring would look better if it can be further subdued and put white on a coloured ground.'[22] Ashley and Alastair Morton developed a good rapport; Morton was himself a designer and Ashley encouraged him to expand his technique and to try his hand at abstract painting.

Edinburgh Weavers was renowned in the artistic world for its production of outstandingly original fabrics which were compatible with contemporary architecture. Morton employed leading artists and went to great lengths to interpret an artist's ideas through the use of subtle textural variation, special printing techniques and original weaves. Ashley remembered Alastair Morton telling him 'to ignore the limitations of the Jacquard looms. He said it was his job together with his assistants to find a way of interpreting my designs in the weaving.' It was clearly a good two-way creative process.

On Burns Night, 1937, Edinburgh Weavers launched their new Lumetuft fabrics. The process offered scope for any individual design to be machine-tufted onto any kind of fabric. An article in the *Cabinet Maker*, 30 January 1937, singles out Ashley's 1936 design *Sylvan* for mention [**88**]. Printed in matt cotton tuffle on a rayon damask, textured oak leaves seem to float over the smooth woven ground. This fabric origi-

88 *above* Textile: *Sylvan (Oakleaf)* 1936–8, woven by Edinburgh Weavers

89 *below* Illustration from Ashley Havinden, *Line Drawing for Reproduction* 1933, showing drawings by Henry Moore

90 *opposite* Textile: *Ashley's Abstract* 1937, screen-print on glazed cotton by Edinburgh Weavers

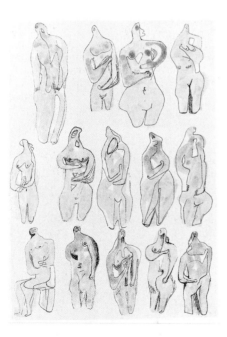

nated in a rug design, *Fontainebleu*, produced for the Duncan Millers' 1936 range. Small-scale drawings for this design point to Ashley's meticulous working method and show his ideas progressing from ink sketch to colour balance tests to experiments with the pattern repeat. *Sylvan* appears to have been renamed *Oakleaf* and was re-issued in 1938 in a less expensive rayon damask weave. With *Uccello*, 1937–8, Ashley returned to the dove and leaf motif, set this time in a geometric framework.

In October 1937 Alastair Morton launched a range of Constructivist Fabrics at Edinburgh Weavers' New Bond Street showrooms, with designs from Ben Nicholson, Barbara Hepworth, Eileen Holding, Arthur Jackson, Winifred Dacre and Ashley. In his opening speech Morton identified two distinct contemporary styles which, he believed, should be developed in interior decoration:

The first would be a contemporary treatment of those objects – leaves and flowers and so forth – with which people always have pleasant associations, but differing as much from the re-drawn Victorian and William Morris [fabrics] *which are on the market today … The second major style genuine to modern interior decoration we considered to be one based on the beauty of pure shapes and colours in the manner of the group of fabrics we are showing to-night. Fabrics by artists whose field is rhythmic beauty of pure shape and space and colour … These fabrics have a place in the best contemporary buildings of today. In some respects they may be before their time. But we are confident that they are the type that the present generation wants.*[23]

While Morton's sympathies lay largely with the second group, Ashley's textiles and those of some of the other Edinburgh Weavers' artists – Marion Dorn, John Tandy, Hans Aufseeser (Hans Tisdall), and Miriam Wornum – fell largely into the first. Even so, Ashley's design for the constructivist range was among the most abstract he produced. *Segment* of 1937 was a two-tone pattern of interlocking concentric circles in green on a cream ground, which was also available in other colourways. However, *Segment* was notably less structured than *Vertical*, Ben Nicholson's fabric for the range. *Vertical* was a heavy woven fabric in white of differing tones and textures based on his white reliefs. Nicholson made several designs for Edinburgh Weavers in the late 1930s and acknowledged the debt he owed to Morton by describing them as being attributable equally to himself and to Morton.[24]

Though Ashley's designs for rugs and fabrics were largely drawn from his own experiments in abstract painting, it is clear that in his textile work he was also playing with the vocabulary of Surrealism. Certain motifs such as the chain and the sharply focused conch shell are redolent of Edward Wadsworth's marine pieces, while the dove that features in several designs was a favoured symbol of the Surrealists. *Ashley's Abstract*, released at the same time as the Constructivist Fabrics, evokes the Henry Moore drawing that Ashley illustrated in his book, *Line Drawing for Reproduction*, 1933. The fabric motifs have perhaps more in common with Moore's increasingly surrealist turn of mind, the figures leaning more towards the informal, fluid, biomorphic aspects of Surrealism than towards Constructivism. *Ashley's Abstract* was

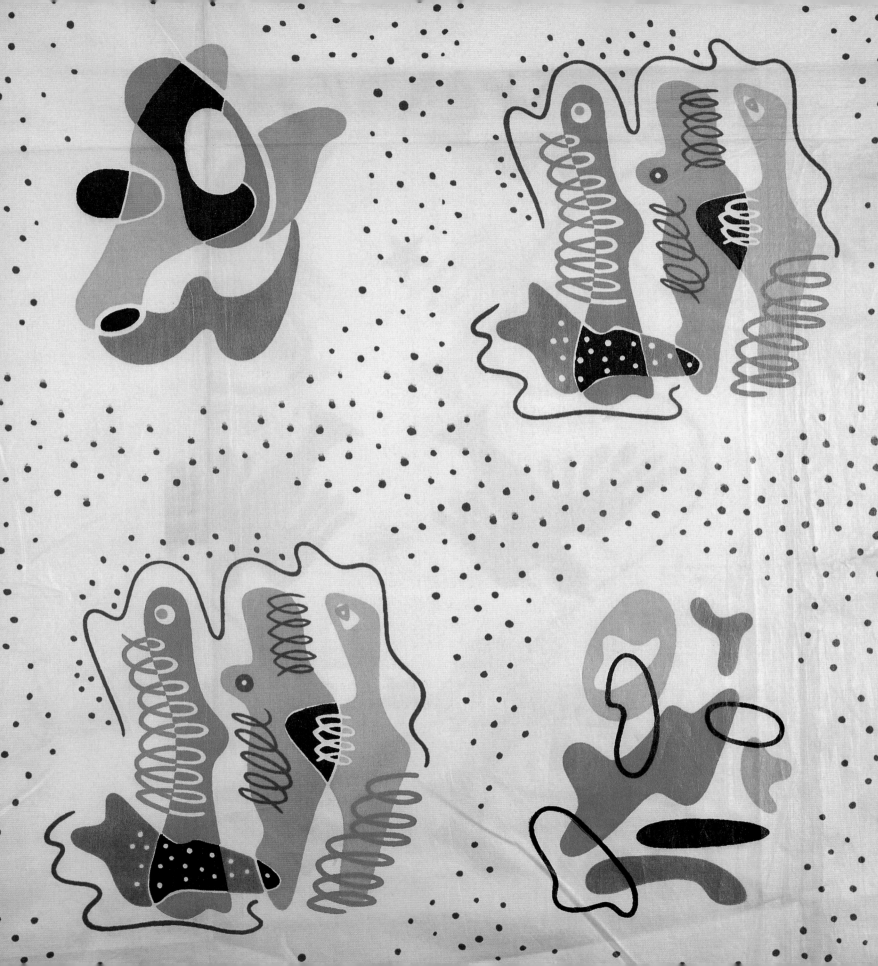

screen-printed on glazed cotton in blue, rust, coral and slate on a blue spotted, cream ground.[25]

The surreal also lurks in the swimming shell motifs of *Marine*, another Ashley glazed cotton, produced by Edinburgh Weavers in July 1937. This may have been aimed at the luxury liner market as Morton had been commissioned to provide fabrics for the *Queen Mary*; another Ashley design of black and white crowns over a pink background was made specifically for this contract [**92**]. The abstract biomorphic shape from *Gnocchi* was worked up into a striped woven fabric called *Abstract Movement*, c.1937. This was used to cover the Havindens' dining room chairs designed by Duncan Miller. Both designs appear to have developed from Ashley's painting called *Composition with Floating Forms*, 1936, which was later reworked as a tapestry woven by the Aubusson factory.

Ashley's textiles featured in several publications between 1937 and 1939. He was one of the subjects of Antony Hunt's article on seven contemporary fabric designers in the January 1938 edition of *Decoration*. To illustrate the article, Hunt used *Maskerade*, 1936. This was a woven design of stars, with vertical wavy lines in blue and white on a pink ground; this ground was woven in a soft matt cotton thread, while the stars gleamed in a shiny rayon in contrasting colours. *Maskerade* was one of a sequence of designs with a vertical linear format [**91**]. *Milky Way*, 1937 (with a theme of stars and comets) and *Alvan* (an intertwined ribbon and chain design) were the others in the series.

Ashley made one design for a dress fabric. He was commissioned by Madame Champcommunal, chief designer for the House of Worth, in 1939. He produced an abstract design in orange, aqua and white on black. Although his textiles were still being illustrated in magazines in 1948, this appears to have been his last.[26]

ASHLEY AND EXHIBITION DESIGN

In 1937, the threads of Ashley's life as a designer were being drawn together. In addition to the three exhibitions of his work in London, he was involved with the Paris International Exhibition, which opened in June 1937 and was also working on the catalogue of the MARS Group exhibition at the New Burlington Galleries, London, in January 1938. At the Paris International Exhibition, Ashley was part of the design team for the British Pavilion, masterminded by the Council for Art & Industry under the chairmanship of Frank Pick. The aim was to display the best of British design, though more at the exclusive than at the popular end of the market. Designed by Oliver Hill, the pavilion contained themed sections on such subjects as sport, the weekend and the cocktail hour, which were used to promote the sort of British goods that were already known to export well: leather, pottery, printed books and textiles. Various artists were asked to contribute to the interior. John Skeaping made a spray-painted frieze, Gertrude Hermes an etched glass window of Britannia, and Clifford and Rosemary Ellis a mosaic floor. There were painted backgrounds by

91 *above* Textile: *Maskerade (Masquerade)* 1937 woven by Edinburgh Weavers

92 *opposite* Textile design for Cunard ship, the Queen Mary, pencil and gouache on paper

93 *above* Design for books and printing stand in the British Pavilion, Paris International Exhibition, 1937

94 *below* Poster design: *Britain Can Make It*, Victoria & Albert Museum, London, 1946

95 *below right* *Britain Can Make It* exhibition at The Victoria & Albert Museum, London, 1946; the menswear section designed by Ashley

Doris Zinkeisen, John Nash, and Eric Ravilious. Ashley was commissioned to design the coloured rubber floor with inlaid motifs symbolic of the various sections, while his Edinburgh Weavers' fabric, *Milky Way*, was exhibited in the textile section.

Ashley was also on the exhibition sub-committee dealing with books, printing and illustration and he designed the stand for this section; Paul Nash, Albert Rutherston and Noel Carrington were members and the group was chaired by Frank Burridge. Ashley's novel solution was to produce a series of giant free-standing open books with inset shelves for display and explanatory texts above and below [93]. For the publicity section he set samples on hinged frames which could be turned like the pages of a book. The British Pavilion was roundly criticised for its dullness, except for Ashley's book section, which was praised in the English and French press.[27]

In 1946, after the war, the Council of Industrial Design returned to the apparently endless and thankless task of raising the standard of British design with the *Britain Can Make It* exhibition at the Victoria & Albert Museum [94]. Yet again the exhibition aimed to encourage manufacturers to be more adventurous in their use of design. Ashley designed both the poster and the menswear section.

Menswear was the last of a sequence of three sections, the others being women's and children's wear, devoted to the theme of postwar clothing. It was placed in a rather cramped position, shared with a section on dress fabrics and cut through by the exhibition's circulation route. The site was further complicated by large structural columns supporting the roof. Used to designing displays for Simpson, Ashley created a modern shop interior, masking the awkward space by creating a new volume within it. A serpentine screen wall was used to create a series of bays to accommodate the displays: day wear, evening wear, formal, town and country wear. Ranged along these

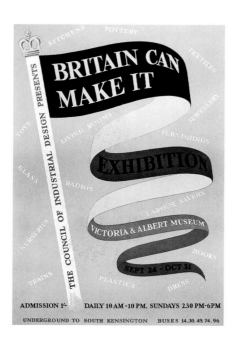

screens and projecting out from the wall was a series of stands, their curvilinear forms echoing those of the gallery itself. Each stand contained a display panel upon which arrangements of clothing were pinned and a row of pillars from which garments were hung. Making a virtue out of necessity, he incorporated the structural columns into the display, encasing them in plastic with small display windows at eye level. To complete the section, a seventeen-foot high mural, showing figures of men in day and evening wear was painted onto a screen wall with the words 'town', 'country' etc. in relief letters [**95**].

The clothes on display were not Ashley's choice; they were chosen to represent what the committee thought were typical of the clothes worn by the exemplarily dressed man of the day. After years of shortages and of having to 'make do and mend', the exhibition was a huge success and was visited by 1.5 million people in three months. In the following years Ashley designed stands for the shipping company South American Saint Line Ltd and for William Hancock Ales at the Industrial Wales exhibition in 1947, and for DAKS Simpson and at the 1948 and 1949 British Industries Fairs.

Ashley was a convinced modernist, producing work that was completely in accord with his time, but he was never 'highbrow' in his modernity. He gave much thought to the question of fine art versus commercial art. He acknowledged the gap between them, but believed that abstract art and its application to everyday life was the binding factor. He believed the advertising artist should practise painting in his spare time, not simply to experiment and to develop ideas for future layouts, but to keep himself in mental trim. The relationships between the curious amoebic shapes in Ashley's paintings, his designs for textiles and the elegant simplicity of his posters are easy to see. His doves, drawn with a single line, the ribbons, the branches and the intertwined circles are telling examples of what stylisation, derived from painting, could create in the realm of modern decoration and design. In the words of H.G. Hayes Marshall: 'Advertising artist, painter, interior decorator, occasionally a forceful writer and last but not least a master organiser, Ashley has left his mark on modern advertising, textiles and modern painting. That should be enough for one man.'[28]

ASHLEY HAVINDEN
ARTIST AND COLLECTOR

Alice Strang

The art critic Herbert Read described the exhibition of paintings by Ashley Havinden at the London Gallery in 1937 as 'the private culmination of a public career'.[1] As the celebrated art director of Crawfords, Ashley was a well established public figure. However, the fact that, for much of his life, he made paintings as well was not as widely known. He received little formal art training and considered his paintings, created in his spare time, as a means of improving his commercial work. They blur the boundaries between 'fine' and 'commercial' art, and reveal the inspiration he found in the work of his artist friends including László Moholy-Nagy and Herbert Bayer, while showing Ashley's own creative talents when unconcerned with the requirements of promotion.

An equally private aspect of Ashley's life was his acquisition, over some thirty years, of a fine art collection. He was part of a very small group of collectors who supported British Modernism in the 1930s and 1940s, buying important works by friends such as Ben Nicholson, Barbara Hepworth and John Piper, then at the beginning of what were to become distinguished careers. After the war, Ashley also developed an interest in a younger generation of artists, including William Scott and William Gear. His collection was displayed, alongside his own paintings, to great effect in his homes at Highpoint II in Highgate, London and Roxford in Hertingfordbury, Hertfordshire.

ASHLEY AS AN ARTIST

Ashley's wide-ranging career illustrates the shortcomings of the definitions of 'commercial' or 'industrial' as opposed to 'fine' art. To make the former, artistic talent is used to create a retail product or to promote a product or event, as seen in textile and poster design. The latter implies an artist producing a work of beauty and significance for its own sake.

Ashley was proud to be, first and foremost, an advertising artist. Indeed, in his book

96 *Gouache no.3* 1937,
gouache on paper, 51.9 × 51.9cm
Private collection

Advertising and the Artist, published in 1956, Ashley argued that advertising was the best way for an artist to communicate their ideas. He reasoned:

The artist has always been able to deliver his 'cargo of ideas' to the cultured, the leisured and the rich; he is now, through advertising, able to make his force felt in the everyday life of millions of people … Modern advertising provides the artist with an immensely wide range of powerful patrons: industrial concerns of every sort and size; the Government also … The result has been to carry the influence of the artist into every home and in some cases round the world as well.[2]

By 1926, Ashley was developing images devised for advertisements into artworks in their own right, as seen in his *Woman Drinking Red Wine* [**97**]. It was precisely the flat, linear art deco style seen in this work that Henry Moore turned upside down when, in 1933, he gave Ashley drawing and carving lessons. Ashley began his unorthodox art training by taking evening classes in drawing and design at the Central School of Arts and Crafts in London from 1922 until 1923, starting soon after he joined Crawfords. He was introduced to Moore at the private view of the sculptor's exhibition at the Leicester Galleries in 1933 and in his unpublished memoir of 1965 recalled:

I was greatly excited by this meeting with Henry Moore – actually the first time I had met a 'pure' artist, as opposed to an 'applied' artist, like myself, working for commerce … In my admiration for Moore and a desire to help him and myself I had a bright idea. Knowing that his main source of income at that time was the few hundred a year he received from the Chelsea School of Art for teaching sculpture, I suggested that as we now both lived in Hampstead perhaps he would give me lessons in carving for two evenings a week. Moore fell in with this suggestion – and we agreed on two guineas a week for him to teach me for an hour from 9 until 10pm on Tuesdays, Wednesdays and Thursdays.[3]

Moore soon decided that before Ashley could learn to carve, he needed to change his approach to drawing from creating outlines, which if composed and executed well would result in attractive images, into one where the outline represented 'the horizon line of a form disappearing from view'.[4]

In 1928 Ashley and his wife Margaret had moved to 20 Alvanley Gardens in West Hampstead, London. They were within walking distance of Moore's studio at Parkhill Road and through him entered what was to become the renowned 'nest of gentle artists' who lived nearby.[5] By 1933 Ben Nicholson and Barbara Hepworth were sharing a studio in the Mall, off Parkhill Road and were neighbours of Herbert Read. Other artists, including Cecil Stephenson and Paul Nash, also moved to Hampstead. Moreover, as the decade progressed, many leading foreign modernists, such as Walter Gropius, Piet Mondrian and Naum Gabo came to live in the area, fleeing the rise of national socialism in mainland Europe. Thus London, and Hampstead in particular, for a short time before the Second World War, became the centre of the international Modern Movement. It was an extraordinary period for British art history and for Ashley personally. He recalled:

97 *Woman Drinking Red Wine* 1926,
watercolour and pen and ink on paper, 36.5 × 29cm
Private collection

We had many happy evenings with Ben and Barbara in Parkhill Road, and I believe they enjoyed their visits to our house in Hampstead when mutual friends like Wells Coates, Johnny and Madeline Duncan Miller, Serge and Barbara Chermayeff, Max Fry and his wife Jane Drew and Harry and Irina Moore were present on different occasions.[6]

Through his friendship with John Duncan Miller, Ashley met László Moholy-Nagy and Herbert Bayer who encouraged Ashley to paint. They had taught typography and advertisment design at the Bauhaus. He recalled:

One of the things which impressed me about Herbert was that in addition to his typography and commercial design work, he regarded it as important to draw and paint as an independent activity. This, partly for its own sake as an aesthetic activity, and partly in terms of 'pure' research as a background to his everyday commercial work. I determined to follow suit – so I started rather tentatively to paint at the weekends.[7]

Ashley's fine art career, therefore, blossomed in the company of pioneers of the Modern Movement, whose ideas he absorbed, interpreted and expressed in abstract works usually executed in gouache on paper and often using an airbrush – techniques which he regularly used in his commercial designs. He was also prepared to make duplicates of his paintings, standard practice when designing images for commercial purposes, and for example, made two virtually identical versions of *Eclipse* in 1935 and in 1936 [**99**]. The inspiration he found in the work of Bayer and Moholy-Nagy, to whom he was particularly close in the late 1930s, is clear in his paintings of this period, as is his admiration for El Lissitzky, who had interested him for several years. At this time, no clear distinction was made between abstract as opposed to surrealist

98 *above* The dining room of Ashley's Highpoint II flat, c.1939. The chairs are covered in Ashley's fabric *Abstract Movement*. On the wall are two of Ashley's works, *Eclipse* and *Solar Movement*.

99 *right* *Eclipse* 1936, gouache on card, 58 × 80cm
Private collection

art and Ashley's paintings of the 1930s reveal a quintessentially English presentation of Modernism, combining rigid geometric planes and lines with biomorphic motifs. His experience painting such works informed the rugs and textiles he began to design shortly afterwards for the Duncan Millers' interior design company and for Alastair Morton of Edinburgh Weavers.

The exceptional Hampstead-centred group of artists, architects and writers was dispersed by the Second World War and Ashley was never to regain such close contact with so many members of the avant-garde. He was unable to resume painting until the late 1940s and in 1949 moved to Hertfordshire, though he remained working in central London. An interest in the work of Edward Wadsworth, John Tunnard and John Armstrong asserted itself in his paintings of this decade, which displayed greater spatial depth and more obviously surrealist elements than before.

In the 1950s, Ashley enthusiastically adopted the Biro as a drawing tool. He revelled in the continuous flow of differently coloured inks and created numerous finely detailed, exuberant and mainly figurative drawings with them. At the same time, his paintings developed into abstract animations of the picture surface, experimenting with the style of Paul Klee and William Gear. Once more the division between fine art and commercial work blurred when two of his paintings appeared in an advertisement he designed for Tootal Fabrics [**100**].

Throughout his professional life, Ashley worked at Crawfords and as the demands of his job and his responsibilities beyond the agency grew, so he had less and less spare time in which to paint. However, after his retirement in 1967, he was able to paint more frequently and began to work on polystyrene, often on a large scale and with huge, vigorous brushstrokes, creating expressive, abstract images full of energy. He was making such paintings when he died in 1973.

Ashley, therefore, created pictures for some forty years. Rather than considering himself an artist frustrated by having to work in advertising, he believed practising as a fine artist improved his commercial work, which to him was the most important expression of his creativity. He explained:

It has always seemed to me that the contemporary designer should paint as an exercise parallel with his normal work. Only in this way can he explore the pure fields of form, colour and spatial relationships for their own sake. I have felt for many years that only by so working can a designer enlarge and extend his powers of expression. When presented with problems requiring the most exact and simple forms of dynamic expression, he is equipped to solve them with greater visual intensity, as a result of his experiments with colour and design.[8]

The pinnacle of Ashley's reputation as an artist is represented by his solo exhibition of paintings in 1937 at the London Gallery, Cork Street, London. Showcasing the breadth of Ashley's talents, it was held at the same time as solo exhibitions of his rugs and textiles and of his typography, press advertisements and posters.[9] Ashley's paintings were included in several group exhibitions of the 1930s, most significantly the

100 Advertisement for Tootal Fabrics, 1950s, with two of Ashley's paintings on the wall

Exhibition of Abstract Paintings by Nine British Artists at the Lefevre Gallery, London in 1939, held at the same time as an exhibition of work by Ben Nicholson.[10] In John Summerson's review in *The Listener*, Ashley's *Solar Movement* was reproduced beneath a white relief by Nicholson.[11] In 1965 Ashley's work was reunited with that of many of the same artists in *Art in Britain 1930–40 centred around Axis, Circle, Unit One* held at Marlborough Fine Art Ltd, London, confirming his place amongst the British Modernists of the 1930s.[12] Yet tellingly, Ashley chose a photograph of himself making a 'Drink Milk' advertisement as his artist's portrait. He was proud to be an advertising artist, who also enjoyed making fine art of distinction.

ASHLEY AS A COLLECTOR

It was precisely because of his career in advertising that Ashley could afford, within limits, to collect works of art. On meeting Henry Moore in 1933, Ashley recalled: 'As much as I admired Moore's carvings, I did not see myself in those days in the role of art patron – that is to say someone who buys works of art – but as another struggling artist.'[13] However, not long afterwards he began, from time to time, to acquire works by friends, including Hepworth, Nicholson and Piper, whom he continued to collect over several decades. After the war he embraced the work of a younger generation, including Bridget Riley and William Scott, eventually building up a significant collection of mainly twentieth-century British art.

In the 1930s and 1940s Ashley was part of a very small group of collectors, which included Leslie Martin and Margaret Gardiner, who recognised the importance of the work being made by the pioneers of Modernism. His acquisitions provided a much needed boost to morale and to the finances of artists then struggling to make ends meet. As Ashley met and exhibited alongside artists including John Piper, Alexander Calder and Arthur Jackson during the 1930s, he began to acquire works. In 1938, Piper, whom he had met in 1934/5 through the Duncan Millers, created an abstract mural for the architect Francis Skinner's flat in Highpoint II, to where the Havindens moved in the same year. Piper made a related painting, the monumental *Black Ground* (or *Screen for the Sea*) which was included in his exhibition at the London Gallery in 1938, where Ashley, who was on the advisory committee, probably acquired it [102].[14] The painting looked extremely striking not only in Ashley's new, modernist flat, but also in the entrance hall of Roxford, the Queen Anne country house he later moved to and where it was joined in the 1960s by Piper's *La Côte de Léon*, 1961[15] and *Pembrokeshire Coast I*, 1962.[16]

Another early acquisition was Arthur Jackson's *Abstract Composition*, 1936, probably also bought from the London Gallery, where it was shown in the 1939 exhibition *Living Art in England*.[17] The importance of this work is shown by its reproduction in the seminal *Circle: International Survey of Constructive Art*, edited by Gabo, Martin and Nicholson and published in 1937.[18] *Circle* brought together images, designs and essays by a wide cross section of artists, architects and writers, including Mondrian,

101 Ashley's flat in Highpoint II, showing his own *Composition with Floating Forms* 1937 alongside works by Gabo, Calder and Hepworth

Le Corbusier and Herbert Read, and highlighted the vital British contribution to the European abstract movement.

During the war, Ashley kept Alexander Calder's mobile sculpture, *The Spider*, c.1938 [**103**] for safe-keeping and later explained:

At the out-break of war my friends the Millers asked me to store one of Sandy Calder's mobiles – 'The Spider' – because they felt responsible for it as Sandy lent it to them for some exhibition purpose. Owing to the war it was impossible to return the mobile to Sandy, so I kept it in Highpoint throughout the war. When in America shortly after the war, I told Sandy about this set of circumstances, and suggested the best way of making arrangements for the mobile to be returned to him in America. He then said: 'Do you like it Ashley?' – when I replied that Margaret and I adored it, he said, "Since you have kept it safely so long, please accept it as a gift from me.[19]

Ashley continued to buy works throughout the 1940s. Hepworth and Nicholson had moved to Carbis Bay near St Ives shortly before the war and when Ashley and his

102 *opposite* John Piper (1903–1992), *Black Ground (or Screen for the Sea)* 1938, oil on canvas, 121.6 × 182.8cm
Scottish National Gallery of Modern Art

103 *right* Alexander Calder (1898–1976), *The Spider* c.1938, painted metal, 104 × 89 × 0.7cm
Scottish National Gallery of Modern Art

family spent a fortnight with them in August 1945, he not only bought Hepworth's beautiful *Wave*, 1943–4 [104] but also met Naum Gabo, who was living nearby.[20] The following year when he returned to Cornwall on holiday, Ashley commissioned Gabo to make a version of *Linear Construction in Space No.1*.[21] *Wave* is one of the first fully realised sculptures that Hepworth made after her move to St Ives to encompass the main strands that were to characterise her work from then on: engagement with the sea and landscape of Cornwall, balance between mass and void, technical brilliance, and a combination of natural, abstract and contructivist forms. It is also one of the first of her works to incorporate colour and strings.

Hepworth's use of strings probably derived from contact with Moore and Gabo. Gabo had moved to Carbis Bay soon after Hepworth and Nicholson, and he and Hepworth worked very closely during this period. It was in Cornwall and whilst working on his *Linear Construction in Space* series that Gabo first used string, rather than incised lines, stretched across and through transparent celluloid frames, to create works of pure abstract Constructivism.[22] This significant departure from his usual practice was to become a recurrent and important feature of Gabo's work.

Ashley remained friends with Hepworth, as he did with many of the artists he met in the 1930s, and continued to support her over the years, acquiring several further works including *Figure (Ascending Form)*, 1956 and *Carving (Mylor)* 1962–3.[23] Hepworth wrote: 'I am simply delighted that you both own *Ascending Form* and it is really a joy to know that it is in your collection. With *The Wave* it gives a *complete* idea of my work – (oval and vertical).'[24]

In 1947 Ashley bought Nicholson's monumental painting, *December 1942 – April 1944* [105].[25] This work exemplifies the colours and beauty Nicholson sensed in his natural surroundings in St Ives, with a continuing exploration of a flat, relief-type composition. While Ashley chose to buy this striking example of postwar Modernism, he also bought an oil by John Tunnard of 1942 and a small sculpture by Reg Butler of 1949 [107].[26] Tunnard's combination of Constructivism and Surrealism influenced Ashley's own paintings of the period, as already noted. Butler, meanwhile, was part of a newly emerging group of sculptors, which included Eduardo Paolozzi and Lynn Chadwick, whose work was described in 1952 by Read as containing 'the geometry of fear'.[27] These varied acquisitions show the breadth of Ashley's interest in art and his wish to keep abreast of new developments.

Enthusiasm for the new work of old friends and of younger artists is clear in the acquisitions Ashley continued to make in his later years. In the 1950s he became interested in the postwar constructivists, in particular Victor Pasmore and Kenneth Martin, whose *Screw Mobile*, 1959 was displayed to great effect in Ashley's studio at Roxford, casting varied and beautiful shadows as it slowly rotated in the air [106].[28] This kinetic sculpture is one of three from a series of ten with a solid central core from which rods of phosphor bronze radiate.[29] As Martin's assistant, Susan Tebby has written:

104 *opposite* Barbara Hepworth (1903–1975) *Wave*, 1943–4, wood, paint and string, 34.5 × 52 × 32cm
Scottish National Gallery of Modern Art

105 *below* Ben Nicholson's painting *December 1942 – April 1944* in Ashley's Highpoint II flat, 1947

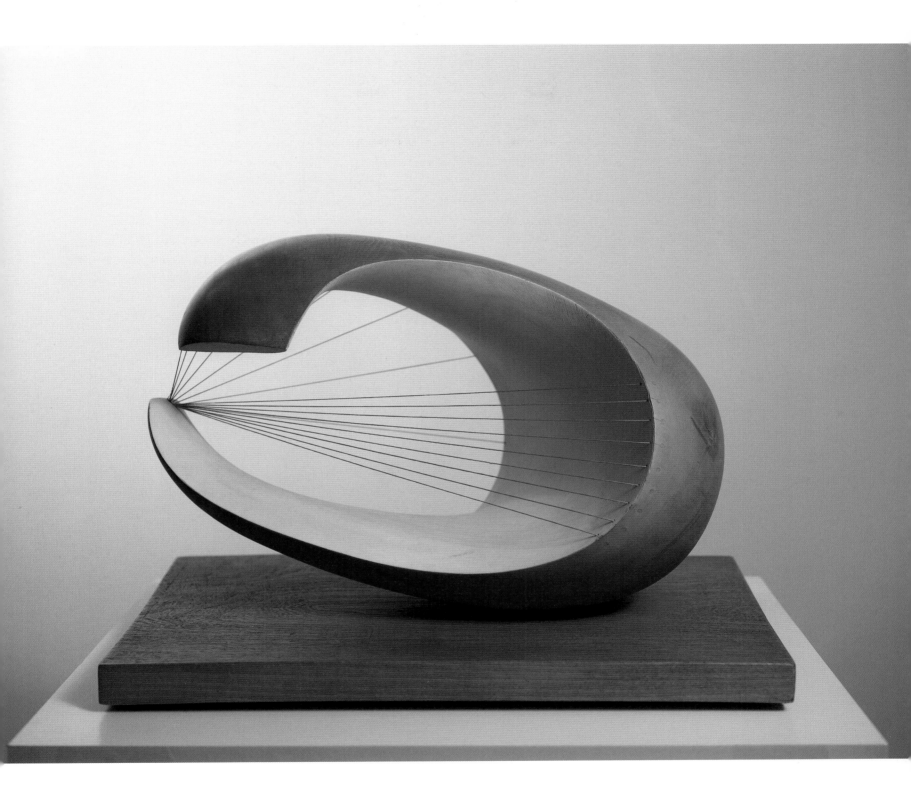

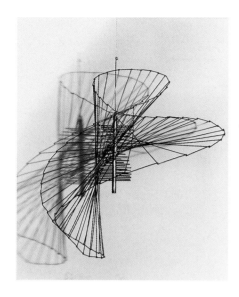

When suspended, the core is perfectly balanced and hangs vertically. When rotating in space, this core takes on the appearance of a solid of revolution as the individual definition of each rod blurs with movement. The solid or revolution varies from an hour-glass figure to a foliate shape within an inverted leaf form, the one metamorphosing into the other according to speed and one's position in relation to the work.[30]

The collection increased with the addition of a painting by the Scottish artist, William Gear, who had caused controversy when an abstract work he had exhibited at the 1951 *Festival of Britain* won a major Purchase Prize.[31] As a member of the CoBrA movement and Ecole de Paris, Gear's use of bright colours and strong, compositional black lines to create works that are often close to stained-glass designs, inspired a new direction in Ashley's own painting.

In the 1960s Ashley embraced op art, a new approach to abstract art in which optical effects gave an illusion of movement, acquiring a print by Bridget Riley and a sculpture by Victor Vasarely.[32] He also bought works by the abstract artist William Scott, including an unusual painting called *Triptych*, 1964.[33] At the same time he acquired recent works by old friends including Hepworth and Piper.

Thus, over forty years, Ashley built up a substantial art collection, only a part of which is discussed here. It bore testimony to his friendship with many leading European artists of the last century and his interest in the work of new and emerging artists, as well as informing his own painting and commercial work. Nevertheless, Ashley could not help but regret the works that he could have acquired, but did not. For example, despite knowing Moore from the earliest days of what was to become an internationally successful career, Ashley acquired only one small work on paper of 1935 by him.[34] Likewise, with hindsight he wished he had bought something by Moholy-Nagy whilst they were close in the late 1930s. In 1971 he lamented: 'I never dreamt of offering to buy any of Moholy's paintings ... How silly I was – so that now, to my great regret, I don't own a single "Moholy" work, which I could have done, for – I suppose, £20 or £30!'[35]

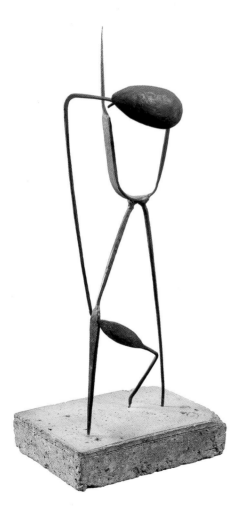

In 1967, on his retirement from Crawfords, Ashley found the time that he needed to devote himself solely to graphic design and painting. In his well-equipped studio in the country, designed by his friend, Maxwell Fry, he was free to design and paint as he wished surrounded by his cherished collection. It is difficult and inappropriate to separate Ashley's work as a painter from the other areas of his creativity, as he bridged 'fine' and 'commercial' art with ease and disliked the notion of their separation. The same influences, interests and talent can be seen in his paintings as in his advertisements, textiles and exhibition design. Indeed, he argued 'the chief qualities of a good poster are those that strike us in the best works of abstract painters. The dynamic arrangement of space, shapes and colours is to be found in each.'[36]

Herbert Read identified the same shared principles underlying fine and commercial art, writing about Ashley:

He is an artist, but he is not a product of the Fine Art tradition. He was born in the original sin of commerce and has attained his state of grace by virtue of the trials and tribulations of a worldly career. His art – an art which takes the form of abstract painting – is the product of his experience. It is not an a priori *art – it is not a formal abstraction unrelated to the objective world. It is implicit in the very different kind of work which has gone before. That is the significant fact: the essential elements in the art of publicity, the elements on which depend its popular appeal and commercial effectiveness – these are in the end abstract elements.*[37]

Following his death in 1973, a group of important works from Ashley's collection was lent to the Scottish National Gallery of Modern Art in Edinburgh. On being informed of the loan of her works, Hepworth wrote to the director: 'I was really delighted to hear that you have those three sculptures in your gallery ... I do hope perhaps, forever, that would make me really happy.'[38] Although Ashley's collection was gradually dispersed, some of the most significant works remain with the Gallery, either acquired for, or given to, the collection, or still on loan. These include Hepworth's *Wave*, Piper's *Black Ground* and Martin's *Screw Mobile*. The archive of Ashley's professional work, along with some of his rugs, textiles and a group of his paintings were deposited at the Gallery during the 1990s. Thus, thirty years after his death, the impressive results of Ashley's artistic and collecting activities are in the safekeeping of a national institution.

REFERENCES

ANON. 1936
'Messrs. Simpson, Piccadilly, w.1'
Architectural Design, June 1936

ANON. 1947
'Contrasting homes of two designers',
House & Garden, Summer 1947, p.18

ANON. 1951
'Ashley Havinden moves', *House & Garden*,
March 1951, pp.36–41

ANON. 1957
'The Creative Art in Advertising: the
Influence of Ashley Havinden', *Art &
Industry*, January 1957, pp.11–15

BOWNESS 1971
Alan Bowness (ed.), *The Complete Sculpture
of Barbara Hepworth 1960–69*, London, 1971

CALVOCORESSI 1978
Richard Calvocoressi, 'Ashley's Textiles',
*The Journal of the Decorative Arts Society
1890–1940*, no.3, London, 1978, pp.4–11

DEWEY 2000
Alice Dewey, 'Barbara Hepworth and Ashley
Havinden: An Artistic Friendship', *Apollo*,
vol.CLII, no.464, October 2000, pp.34–41

DUNCAN MILLER 1937
John Duncan Miller, *Interior Decorating*,
How to do it series, London, 1937

EDINBURGH 1978
*Alastair Morton and Edinburgh Weavers:
Abstract Art and Textile Design 1935–46*, exh.
cat., Scottish National Gallery of Modern
Art, Edinburgh, 1978

FROSTICK 1970
Michael Frostick, with a prologue by Ashley
Havinden, *Advertising and the Motor-car*,
London, 1970

GOWING 1957
Mary Gowing, 'The Creative Art in advertis-
ing: the influence of Ashley Havinden', *Art
& Industry*, January 1957, pp.11–15

HAVINDEN 1933
Ashley Havinden, *Line Drawing for Repro-
duction*, London, 1933, revised edition 1941
(reprinted 1945 and 1949)

HAVINDEN 1937
Ashley Havinden, 'Visual Expression',
paper given at 63rd dinner of the Double
Crown Club, 18 November 1937
[published in *Typography*, 1938]

HAVINDEN 1956
Ashley Havinden, *Advertising and the Artist*,
London, 1956

HAVINDEN 1965
Ashley Havinden, 'Autobiographical Notes'
(unpublished), 1965, in Ashley Havinden
Archive, Scottish National Gallery of
Modern Art, GMA A39/1/071

HUNT 1938
Antony Hunt, 'The Artist and the Machine,
a study of Seven Contemporary Fabric
Designers', *Decoration, no.27 (new series)*,
London, January – March, 1938, p.30

HAYES MARSHALL 1939
H.G. Hayes Marshall, *British Textile
Designers Today*, Leigh-on-Sea, 1939

LONDON 1965
Art in Britain 1930–40, exh. cat.,
Marlborough Fine Art Ltd, London, 1965

LONDON 1979
*Thirties: British Art and Design before the
War*, exh. cat., Hayward Gallery for the Arts
Council of Great Britain, London, 1979

LONDON 1999
Modern Britain 1929–1939, exh. cat., Design
Museum, London, 1999

READ 1937
Herbert Read, 'Ashley Havinden and the art
of publicity', *Typography*, no.3, Summer
1937, pp.8–10

ROSNER 1952
Charles Rosner, 'Artists into Art Director',
Graphis, no.39, 1952

SANDERSON AND LODDER 1985
Colin Sanderson and Christina Lodder,
'Catalogue raisonné of the constructions and
sculpture of Naum Gabo' in Steven Nash and
Jörn Merkert (eds.), *Naum Gabo: 60 Years of
Constructivism*, Munich, 1985

SAXON MILLS 1954
G.H. Saxon Mills, *There is a tide …*
[history of Crawfords], London, 1954

WAINWRIGHT 1996
David Wainwright, *The British Tradition:
Simpson – a World of Style*, London, 1996

YORK 1980
John Havinden: Shapes of Things to Come,
exh. cat., Impressions Gallery, York, 1980

ARCHIVAL MATERIAL GMA A39

Ashley Havinden Archive, Scottish National
Gallery of Modern Art, Edinburgh consists
of over 50,000 items. The material is divided
into eleven sections as follows: documents:
Ashley & W.S. Crawford files/01; portfolios/
02; artworks/03; publications and printed
ephemera/04; photographs/05; printed
material by other artists/06; publications and
cuttings collected by Ashley Havinden/07;
slides and negatives/08; sketchbooks and
scrapbooks/09; textiles/10; indexes to
Ashley's work/11.

Further material relating to W.S. Crawford
Ltd is in the History of Advertising Trust
Archive, Norwich.

Further material relating to Simpson
Piccadilly is found in the DAKS-Simpson
Archive, London. Papers relating to Alastair
Morton and Edinburgh Weavers can be found
in The Morton Papers, National Archives of
Scotland, Edinburgh; Morton of Darval
Muniments GD.326; and in the Archive of
Art and Design, Victoria & Albert Museum,
London, AAD 1978/4 and AAD 1991/3.

NOTES

Ashley Havinden
Advertising and Art
pages 27–55

Note: unreferenced material is from Ashley's writings held in the Ashley Havinden Archive

[1] Sir Charles Higham, *Advertising: Its Use and Abuse*, London, 1925, p.69.

[2] Frostick 1970, pp.10–11.

[3] Dorothy L. Sayers, *Murder Must Advertise*, London, 1933, p.38.

[4] The building still stands, and is now listed. Ashley's chrome numbering '233' is intact at street level. Sir William Crawford set the cost of the building against tax, a move that was challenged in the courts by the Inland Revenue. Asked if it was necessary to create such a grand impression on clients, under examination, Sir William replied to the prosecuting barrister: 'Sir, is it perhaps necessary for you yourself to dress in your present attire – to create an impression?' Crawford won the case.

[5] E. McKnight Kauffer (1890–1954) was an American artist, designer and illustrator who lived in England between the First and Second World Wars. Much admired at the time, his eclectic, bravura stylisations rarely matched the standards of his book, *The Art of the Poster*, London 1924. See Mark Haworth-Booth, *E. McKnight Kauffer: a designer and his public*, Gordon Fraser Gallery, London, 1979.

[6] Read 1937, p.9.

[7] Well before the First World War, these artists were masters of the *Sachplakat* (straightforward and slogan-free) which made direct, simplified illustrations of the poster subject. Ludwig Hohlwein (1874–1949) was the best known, and went on to design Nazi propaganda in the 1930s. Lucian

Bernhard (1883–1972) who Crawford and Ashley also visited designed several typefaces for German and American foundries, and one script face produced in England. Bernhard emigrated to the United States in 1923, although he kept on a business in Berlin.

[8] Frostick 1970, p.22.

[9] Ibid., pp.21–2.

[10] Herbert Read (1893–1968) was a poet, writer and art critic. He was a supporter of avant-garde, especially abstract, artists in the 1930s. Read and Ashley helped with the emigration to Britain of Moholy-Nagy and Mondrian. Read was a university professor in Edinburgh (1931–3).

[11] Herbert Read, *Art and Industry*, London, 1934.

[12] Read 1937, pp. 9–10.

[13] Ibid.

[14] Ibid., p.10.

[15] Havinden 1937.

[16] Ibid.

[17] *The Bystander*, 16 March 1938.

[18] Ashley Havinden, 'The Importance of Company Handwriting', *Penrose Annual*, 1955, not paginated.

[19] The diagonal stripes, and the areas of colour with brushmarked edges, were features of Ashley's abstract paintings.

[20] Lecture to the Institute of Practitioners in Advertising, 12 December 1956, typescript Scottish National Gallery of Modern Art Ashley Havinden Archive GMA A39/01/179.

[21] Ashley's typescript notes of a lecture at the Institute of Practitioners in Advertising, 12 December, 1956.

[22] Ibid.

[23] Havinden 1956, p.14.

[24] *Advertisers Weekly*, 20 November 1964.

Ashley Havinden
Architecture and Interiors
pages 57–77

[1] F.H.K. Henrion, 'Design's Debt to Ashley', published in the *Penrose Annual* 1974. Henrion emigrated to Britain from Germany in 1936. During the last years of the 1930s he worked with Havinden at W.S. Crawford Ltd. After the war he became president of the Society of Industrial Artists and Designers, and worked on several key exhibitions including *Britain Can Make It* (1946) and the *Festival of Britain* (1951). He was a pioneer of 'Corporate Identity' in Britain and was art director at the ICA in London during the 1950s.

[2] William Crawford, *Introduction to Modern Publicity*, London 1930; see also 'Movement' in *Gebrauchsgraphik (London special issue)* April 1937, p.25.

[3] The Gorell Committee *Report on Art and Industry* was published in 1933. The committee acknowledged that the unsatisfactory relations between art and industry were deep seated in national life and could only be altered by a major change of attitude. They recommended the setting up of a centre for modern design in London. Design was seen as the agent and outcome of social change and reform.

[4] Havinden 1965. Unless otherwise stated all subsequent quotations from Ashley's writings come from these autobiographical notes, written originally for an exhibition at Marlborough Fine Art but not used in the catalogue (London 1965).

[5] The *Abnormal Importation Act* of November 1931 put a fifty percent duty charge on the import of textiles; the 1932 *Import Duties Act* added twenty percent duty to all goods.

[6] Russian-born Serge Chermayeff (1900–1996) moved to England in 1910. In the late 1920s he directed Waring and Gillows Modern Art Studio before setting up an independent practice in 1931–3. He was a member of the MARS (Modern Architectural Research) Group and designed the De La Warr Pavilion in Bexhill-on-Sea with Eric Mendelsohn 1933–6. He moved to the USA in 1939.

[7] Havinden 1937. The Double Crown Club was founded in 1924 as a dining club for typographers and printers.

[8] Herbert Read, *Art and Industry*, London 1934. Ashley owned a first edition of the book.

[9] Frinton Park was a remarkable example of British modernist housing development built at Frinton-on-Sea, Essex in 1934. Oliver Hill was lead architect for the development. Wells Coates, Joseph Emberton, Frederick Etchells and Maxwell Fry all produced designs for individual houses.

[10] Ashley Havinden, 'Prologue', Frostick 1970.

[11] After the Second World War Thomas formed ARCON (Architects Construction and Consultants). Thomas introduced Agar to Ashley, who in turn was responsible for introducing Agar to Paul Nash at Swanage in 1935.

[12] Derek Patmore, 'British Decorators of Today I: Rodney Thomas', *The Studio*, vol.103, August 1932 p.294.

[13] See York 1980.

[14] 'Contrasting Homes of Two Designers. Ashley Havinden and Cecil Beaton', *House and Garden*, Summer 1947, pp.17–18; Anon, 'Ashley Havinden Moves', *House and Garden*, March 1951, pp.37–41.

[15] Hunt 1938, p.30. Hunt ran the London showrooms of Edinburgh Weavers and acted as their public relations man.

[16] Ashley transcript of article quoted in Hayes Marshall 1939.

[17] 'Carpets for the New Flat', *Vogue*, 1 October, 1930.

[18] Alison Haig, 'Pins and Needles', *Night & Day*, 16 September 1937.

[19] Photographs of the Straights' fashionable London flat were published in several journals including *The Studio*, vol.114, July–December 1937 and *Harper's Bazaar*, February 1938.

[20] From an article on Ashley's new fabrics for Edinburgh Weavers in *The Cabinet Maker*, 14 December 1937, quoted in Calvocoressi 1978, p.12.

[21] Hunt 1938, p.30.

[22] Transcript letters from Alastair Morton to Ashley Havinden, 14 March and 27 May 1936; GMA A39/01/171.

[23] Drafts of Morton's speech at the launch of the Constructivist Fabric range, London, October 1937 are in the National Archives of Scotland, GD 326/164. The final draft is reproduced in Edinburgh 1978, pp.35–7.

[24] Letter from Ben Nicholson to Richard Calvocoressi, 18 February 1978, quoted in Calvocoressi 1978, p.11.

[25] The gouache design for this fabric is in the V&A Department of Prints and Drawings, CIRC 46–1971.

[26] The Ashley Havinden Archive contains a sample of a later fabric produced by Edinburgh Weavers. This is not signed or labelled as being by Ashley and stylistically probably dates from the 1950s. This was when Alastair Morton was producing a second series of artists' textiles.

[27] Ashley's contribution to the exhibition was reviewed in *The Studio*, London, vol.114, July – December 1937, p.175; *Courier Linotype*, September – October 1937; and *Toute l'Edition*, Paris, 11 September 1937. These are in Ashley's very comprehensive cuttings books; GMA A39/11/5–7.

[28] Hayes Marshall 1939, p.191.

Ashley Havinden
Artist and Collector
pages 79–89

[1] *Paintings by Ashley Havinden*, London Gallery, London, 5–28 August 1937. Read 1937, p.10.

[2] Havinden 1956, p.11.

[3] *Sculpture and Drawing by Henry Moore*, Leicester Galleries, London, February 1933. Havinden 1965, p.5.

[4] Havinden 1965, p.5.

[5] Herbert Read, 'A Nest of Gentle Artists', *Apollo*, vol.no.LXXVII, no.7 (new series) September 1962, pp.536–40.

[6] Havinden 1965, p.15a.

[7] Havinden 1965, p.10.

[8] Ashley Havinden, typescript titled 'Article 1952–53 Worlds Press News – ready to appear in connection with 'Outdoor Advertising' feature when required', A39.1.173b, not paginated.

[9] At Duncan Miller Ltd, London, 10–31 August 1937 and Percy Lund Humphries, London, 12–31 August 1937, respectively.

[10] March 1939. The other artists shown were Tunnard, Morton, Stephenson, Jackson, Johnstone, Glass, Wright and Evans.

[11] John Summerson, 'Abstract Painters', *The Listener*, vol.XXI, no.531, March 1939, pp.574–5.

[12] March – April 1965.

[13] Havinden 1965, p.10.

[14] The work is now in the collection of the Scottish National Gallery of Modern Art, GMA 1998, purchased 1978. Ashley was a member of the Gallery's advisory panel for England with Herbert Read and Henry Moore. The panel also included Bayer (Austria), Gropius (Germany), Breuer and Moholy-Nagy (Hungary) see Havinden 1965, p.16.

[15] Sold as lot 44, Phillips London, 23 April 1979.

[16] Private collection, UK.

[17] January – February 1939, no.17. Sold as lot 20, Christie's London 22 October 1997.

[18] Leslie Martin, Ben Nicholson and Naum Gabo (eds.), *Circle: International Survey of Constructive Art*, London, 1937, 'Section 1: Painting', repr b/w pl.19.

[19] Havinden 1965, p.16. This work is now in the collection of the SNGMA, GMA 1586, purchased 1976.

[20] Bowness 1971. *Wave* is now in the collection of the SNGMA, GMA 4305, acquired in 1999 with support from the Heritage Lottery Fund, the National Art Collections Fund, the Henry Moore Foundation and donations from the public.

[21] Sanderson and Lodder 1985, no.48. 11. Ashley's *Linear Construction in Space No.1* is now in the collection of the Hirshhorn Museum and Sculpture Garden, Smithsonian Institution, Washington (no.66), 1976.

[22] Ibid., p.229.

[23] Bowness 1971, nos. 219 and 322 both now in private American collections.

[24] Undated manuscript letter from Barbara Hepworth to Margaret and Ashley Havinden, dated to 1950 by Michael Havinden, private collection UK.

[25] Present whereabouts unknown.

[26] John Tunnard, *Assault*, c.1942, Alan Peat and Brian A. Whitton, 'Catalogue of known oils, watercolours, drawings and mixed-media works', *John Tunnard: His Life and Work*, Aldershot, 1997, no.235. Sold as lot 251, Christie's London, 8 November 1985, and Reg Butler, *Personage*, 1949, now in the collection of the SNGMA, GMA 1661, purchased 1977.

[27] Herbert Read in the catalogue for *Exhibition of works by Sutherland, Wadsworth, Adams, Armitage, Butler, Chadwick, Clarke, Meadows, Moore, Paolozzi, Turnbull*, British Pavilion, Venice Biennale, 1952.

[28] This work was presented to the SNGMA, by the Executors of Ashley's estate in 1976, GMA 1590.

[29] The other two are *Screw Mobile with Cylinder*, 1956 in the Arts Council Collection, and *Screw Mobile with Black Centre*, 1959–61 in the Tate collection (T00752).

[30] Susan Tebby, 'The Early Screw Mobiles of Kenneth Martin', draft 10 August 2003. We are very grateful to Professor Susan Tebby for allowing us to quote from this unpublished essay.

[31] William Gear, *Vertical Study*, 1953, sold as lot 295, Christie's London, 8 November 1985.

[32] Bridget Riley, *Screen Print on Plexiglass no.5*, no.45/75, 1965, private collection, UK. Victor Vasarely, *Metal 1.*, 1963, present whereabouts unknown.

[33] *Triptych*, 1964, on loan to the SNGMA from a private collection.

[34] *Reclining Figure*, 1935, private collection, Ann Garrould (ed.), *Henry Moore, vol.2: Complete Drawings 1930–39*, London, 1998, no.AG 35.57 / HMF 1149.

[35] Manuscript letter of 6 January 1971 to Terence A. Senter of the University of Nottingham, A39.1.151.

[36] Ashley Havinden quoted in René Elvin, 'The Work of a Great English Advertising Man: Ashley Havinden', 1952/3, typescript, A39.1.173b.

[37] Read 1937, p.9.

[38] Typewritten letter of 13 March 1975 to Douglas Hall, SNGMA Archive.

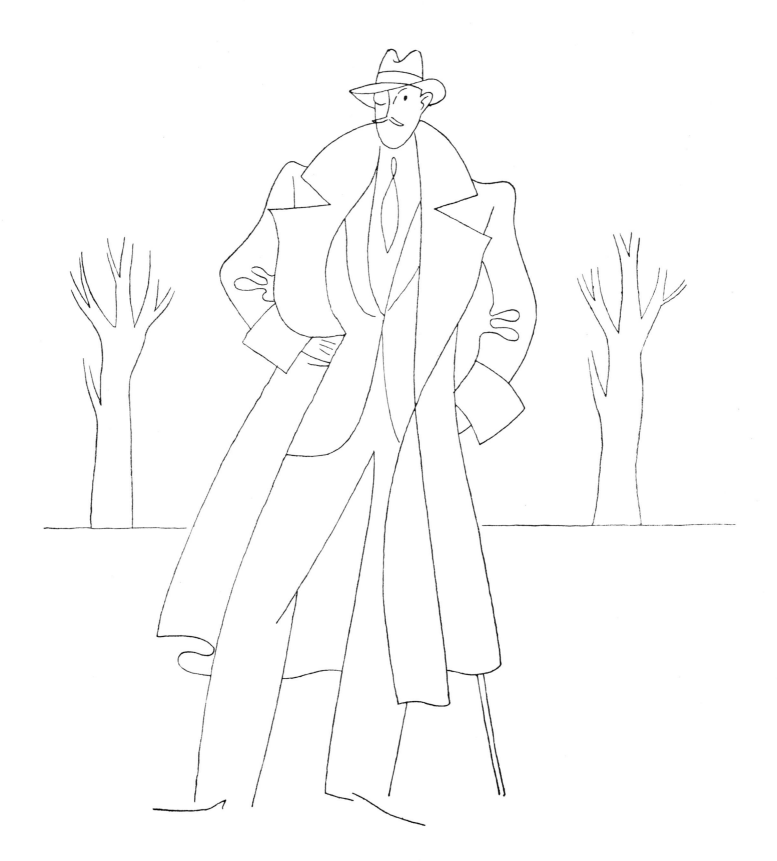

ASHLEY